IMAGES
of America

THE BLACK CANYON
OF THE GUNNISON

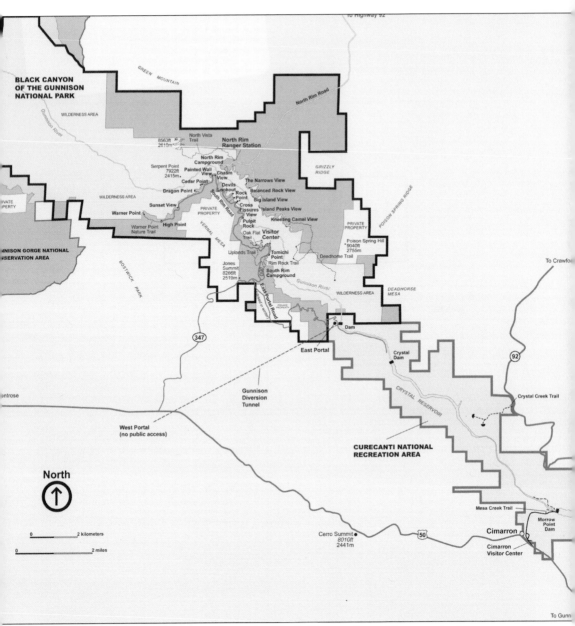

THE BLACK CANYON. This map shows the Black Canyon from Cimarron looking west and includes Black Canyon National Park. Black Canyon National Monument was created in 1932 and became Black Canyon National Park in 1999. (Courtesy National Park Service, U.S. Department of the Interior.)

ON THE COVER: A lone figure stands on the Denver and Rio Grande (D&RG) narrow-gauge railroad tracks deep in the Black Canyon, near the mouth of Cimarron Canyon, in 1909. The Rio Grande ran through the upper section of the canyon for 15 miles between Sapinero and Cimarron, but then had to leave the gorge when it became too dangerous for rail lines. (Courtesy W. T. Lee, U.S. Geological Survey.)

IMAGES
of America

THE BLACK CANYON
OF THE GUNNISON

Duane Vandenbusche

ARCADIA
PUBLISHING

Published by Arcadia Publishing
Charleston, South Carolina

Printed in the United States of America

Library of Congress Control Number: 2009920013

For all general information contact Arcadia Publishing at:
Telephone 843-853-2070
Fax 843-853-0044
E-mail sales@arcadiapublishing.com
For customer service and orders:
Toll-Free 1-888-313-2665

Visit us on the Internet at www.arcadiapublishing.com

This book is dedicated to my former colleague, Dr. William Edmondson, a great teacher and a great friend.

CONTENTS

ACKNOWLEDGMENTS

Many people, libraries, and museums are to be thanked for the use of photographs in this book. The Denver Public, Colorado State Historical, Montrose, and Western State College Libraries were of immense help in tracking down and providing photographs. Bobbie Glover, secretary of the Uncompahgre Valley Water Users Association, and Deb Barr, of the Montrose Museum, were invaluable in allowing me to go through their outstanding collections of pictures.

Individuals who played a major role in putting together *Black Canyon of the Gunnison* include local photographers Lisa Lynch and Neil Santerella. Jim Newberry of Cimarron, one of the great climbers in Black Canyon history, was most generous with his photographs and information. Dan Nelson of Montrose and Leah McEarchen of Glenwood Springs were most generous in providing photographs and information about their father, Ed Nelson. Two local museums provided pictures and information. The Gunnison Pioneer Museum, featuring the historic Paragon School and Denver and Rio Grande narrow-gauge engine 264, furnished many photographs. The Crested Butte Mountain Heritage Museum housed in the historic Tony's Conoco Gas Station on Elk Avenue was also a bonanza in providing photographs and information.

Through the years, my interviews with old-timers like Tony Danni, John Harrington, Art Pearson, Joe and Pearl Wright, Lyle McNeill, Bruce Hartman, Grant Youmans, Ed Nelson, and many others have greatly added to the information in this book. The memoirs of Lowry Englebright, Harry Cornwall, and Alonzo Hartman and the early research and writings of Betty Wallace were also of great value to me.

I am very grateful for the support, guidance, and wisdom of editor Jerry Roberts and Arcadia Publishing. Special thanks go to Pam Williams, who scanned all the pictures in this book. Her expertise and wise counsel were of enormous importance to me. And for all the old-timers of the Gunnison country: a special salute for the kindness and information you have so generously given me. Lastly, I thank the people of St. Nicholas in the Upper Peninsula of Michigan, the Belgian farming community in which I grew up, for the inspiration they have given me.

INTRODUCTION

The Black Canyon of the Gunnison River is one of the great gorges in the United States. The canyon begins at the old railroad town of Sapinero, 26 miles west of Gunnison, deep in the Rocky Mountains on Colorado's Western Slope, and, with the Gunnison River roaring through it, ends 53 miles downstream near the town of Lazear. The canyon walls are 500 to 2,700 feet high, and the Gunnison River drops a stunning 43 feet per mile through it, six times more than the Colorado River through the Grand Canyon. In one sensational mile in the canyon, the river drops 268 feet without any major waterfalls. The Gunnison River in the Black Canyon is the steepest falling river in the United States with the exception of the Yellowstone. Early Ute Indian trails dropped into the bottom of the gorge, but the Utes feared the Gunnison River far below, referring to it as "much rocks, big water." The Black Canyon contains famous landmarks—Curecanti Needle, Chipeta Falls, the Narrows, Chasm View, Kneeling Camel, Serpent Point, and the Painted Wall.

The canyon was called "Black" because of its depth, its dark and vertical walls, and because in sections of the gorge, the sun shines only 33 minutes a day. Some canyons of the American West are longer and some are deeper, but none combines the depth, sheerness, narrowness, darkness, and dread of the Black Canyon.

Explorer John Gunnison, hoping to find a transcontinental railroad route between St. Louis and San Francisco in 1853, was shocked when he peered into the Black Canyon for the first time. Perpendicular walls 2,700 feet high, along with roaring, turbulent white water and almost continuous twilight, made a railroad route impossible.

In 1881, William Jackson Palmer's narrow-gauge Denver and Rio Grande Railroad approached the Black Canyon as it headed west. Surveying was done in January with men, horses, and wagons lowered down the steep slopes by ropes. At the bottom of the ominous and silent gorge, surveyors picked their way through on the ice and water of the Gunnison River and conducted tests.

Construction of the railroad in the canyon began during the summer of 1881. For over a year, an army of Irish and Italian laborers blasted out a roadbed from Sapinero to Cimarron, 15 miles away. The cost of building the road through the canyon was staggering—$165,000 a mile.

Hoping to run his railroad along the Gunnison River through the rest of the Black Canyon, William Palmer sent in a survey team in December 1882. The team was led by Palmer's top engineer, Byron Bryant, who had a crew of 12 men. Bryant expected to make his journey in 20 days; it would actually take him 68. Eight of the twelve-man crew left after a few days, terrified of the task in front of them. What the rest of the men saw was spectacular and had never been seen by another human. The raging Gunnison River was dangerous enough, but at different sections of the canyon, huge rocks had fallen off the vertical walls and buried the river. At one section called the "Narrows," the canyon narrowed to 44 feet with canyon walls over 2,000 feet high.

The Bryant survey team was forced to climb into the canyon every morning and out at the end of each day. In February, the job was finished. Bryant's report to Palmer stated it would be impossible to build anything in the depths of the Black Canyon. "The canyon," he said, "was impenetrable."

In August 1901, the newly created U.S. Reclamation Service convinced the U.S. Geological Survey to conduct a scientific survey in the Black Canyon where Bryant had been nearly 20 years before. The survey would look for a site for a diversion tunnel to carry Gunnison River water into the nearby arid Uncompahgre Valley. Thus began one of the most famous and dangerous expeditions of the American West, featuring Abraham Fellows and William Torrence.

Fellows had an engineering degree from Yale, and Torrence was a native of nearby Montrose and familiar with the canyon just below Cimarron. Their expedition lasted 10 days. With only hunting knives, two silk lifeline ropes, and rubber bags to encase their instruments, the two men left Cimarron and headed downstream into terra incognita. They crossed the Gunnison River 76 times with no knowledge of what lay before them. Climbing, swimming in roaring and cold water, and walking, they found a tunnel site. Eight years later, the Gunnison Tunnel, the first great Bureau of Reclamation project in history, was finished. Pres. William Howard Taft came to Montrose to throw the switch that started water flowing through the 6-mile tunnel. The year 2009 marks the 100th anniversary of that great event, which saved the Uncompahgre Valley and its citizens.

The Black Canyon became a national monument in 1932 and a national park in 1999. Nearly 250,000 tourists a year come to visit one of the great natural wonders of the United States. Today the Black Canyon stands as a monument to the rugged, violent, and wonderful landscape of Western Colorado.

One

THE BEAUTY OF IT ALL

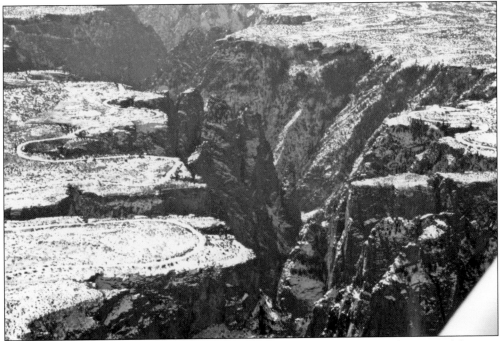

BLACK CANYON BEAUTY. The Black Canyon is stunningly beautiful during all seasons of the year. This December picture shows it off in its white and wintery beauty. Far below, the sun is almost nonexistent at this time of the year and temperatures are very cold.

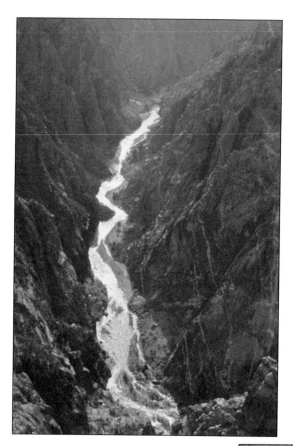

INTO THE DEPTHS. The Black Canyon, with the Gunnison River below, gives off a feeling of danger. The canyon sometimes narrows to almost the width of the river and is all gloom and grandeur. The canyon has often been called a state of mind rather than a place.

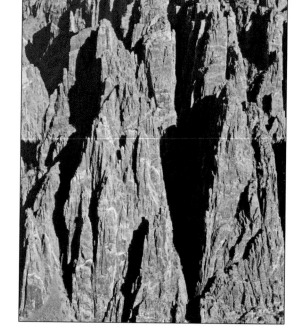

PILLARS OF THE BLACK CANYON. These magnificent rock formations in the canyon are over 2,000 feet high and are evidence of the erosive activities of ice and water over the course of millions of years.

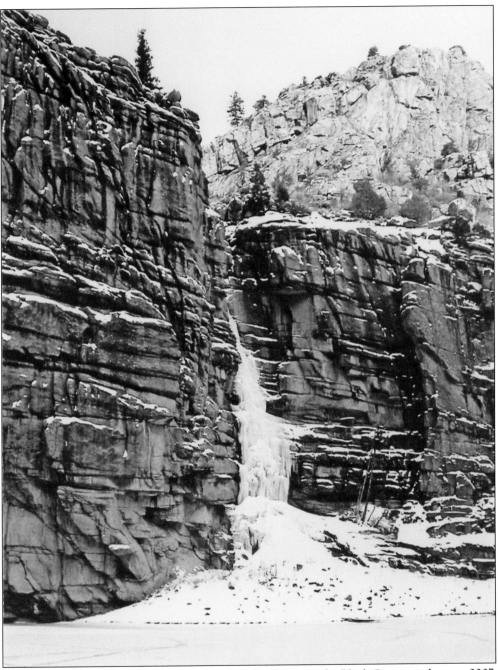

WINTER IN THE CANYON. Beautiful Chipeta Falls lies frozen in the Black Canyon in January 2007. The iced-over Gunnison River below serves as one of the longest ice rinks anywhere, making it a wonderland for ice-skaters from the Gunnison and Uncompahgre Valleys.

CANYON SPLENDOR. In 1911, author Eugene Parsons described the Black Canyon as colored by "needles of highly colored sandstone pointing skyward, trees growing out of cliffs and a brilliant strong river darting in swift, green chutes . . . dancing in creamy eddies."

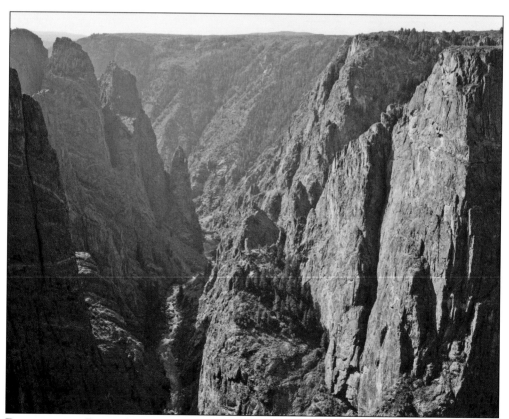

DEPTHS OF THE BLACK CANYON. Some canyons in the American West are deeper and longer, but none combines the depth, sheer cliffs, narrowness, and dread of the Black Canyon. The canyon's depth and narrowness give it the name Black Canyon.

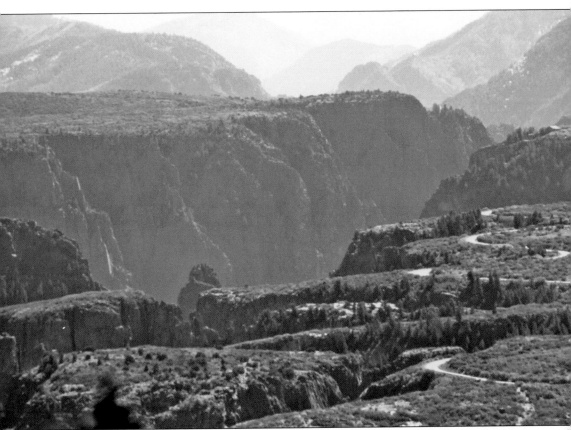

BLACK CANYON PANORAMA. Beginning 26 miles west of Gunnison near the now-flooded village of Sapinero, the canyon snakes its way for 53 miles. En route through the gorge, the Gunnison River crashes over waterfalls, welcomes roaring side streams, and bypasses huge boulders.

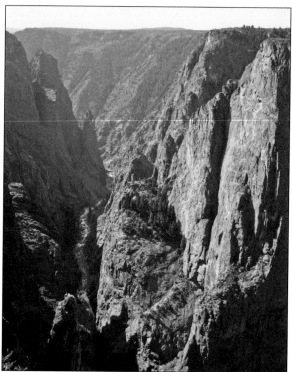

STEEPLY FALLING GUNNISON RIVER. The Gunnison River in the Black Canyon falls an average of 43 feet per mile. In comparison, the Colorado River in the Grand Canyon only drops 7 feet per mile. Aside from the Yellowstone River, the Gunnison River in the Black Canyon is the steepest falling river in the United States.

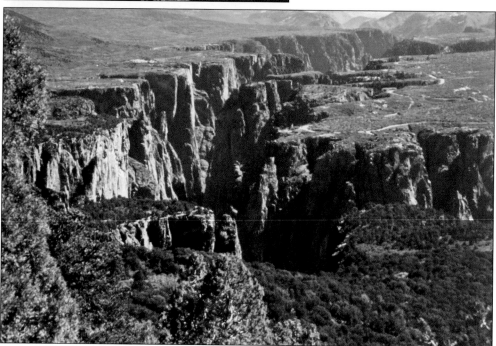

BLACK CANYON FROM THE TOP. The rugged nature of the Black Canyon is shown here. Vertical walls, tremendously steep side ravines, and a lack of sunlight make the canyon ominous. At one point in the Black Canyon, it is only 1,300 feet from the north to south rim, making it twice as deep as it is wide.

BLACK CANYON LOOKING WEST. The canyon is from 500 to 2,700 feet deep and is complete with spectacular waterfalls, trees growing out of cliffs, and the roaring Gunnison River careening through it. The canyon is fraught with danger because of its sheer cliffs and dangerous rock and snow slides.

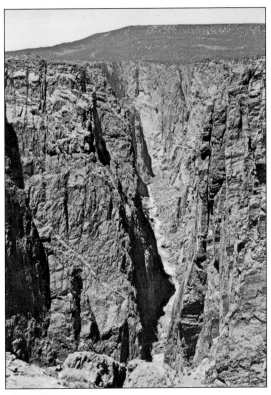

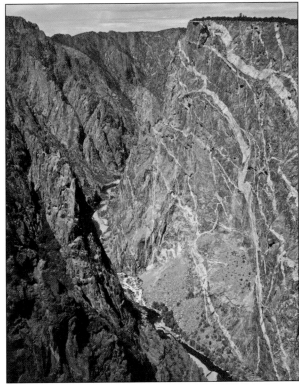

PAINTED WALL. Lines of pink granite decorate the Black Canyon's famous Painted Wall. This spectacular wall is in the Black Canyon of the Gunnison National Park and is one of the most viewed points of the gorge.

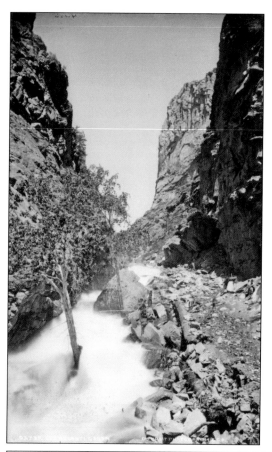

CURECANTI CANYON. Water from Curecanti Creek roars down the canyon in the 1890s. The tremendous drop of the water carried rocks, mud, and logs into the Gunnison River in the Black Canyon. Curecanti Creek runs into the Black Canyon from its north rim.

PROPOSED BLACK CANYON BRIDGE. Because of the success of the newly opened Royal Gorge Bridge near Canon City in 1929, town officials from Montrose and Gunnison proposed a bridge over the Black Canyon the following year. It was felt that the canyon top at the bridge site was only 800 feet wide from the south to the north rim and that the river bottom below was only 8 feet wide. This fantastic idea never got off the ground because of the cost as well as the Depression.

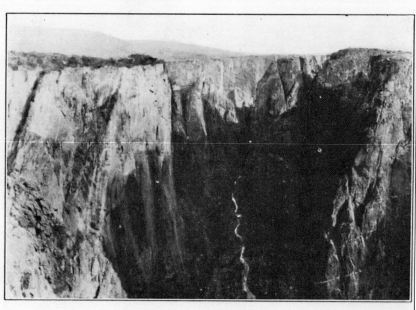

Site of Proposed Suspension Bridge at Black Canon National Monument. 1300 feet across, 2,000 feet deep, to Gunnison River.

SIDE CANYON DANGER. There are many side canyons that descend into the Black Canyon and Gunnison River. All presented danger, especially in the spring when runoff carried rocks, mud, and debris into the Black Canyon. German brown and rainbow trout had great spawning beds in the side canyons as they neared the Gunnison River.

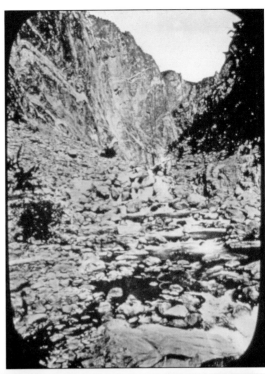

BIG DROP ON THE GUNNISON. Below the East Portal of the Gunnison Tunnel in the Black Canyon, the Gunnison River dropped precipitously. With huge rocks narrowing the stream, the water was forced into one waterfall after another. In one sensational mile, the Gunnison River drops a stunning 268 feet and is very difficult to navigate.

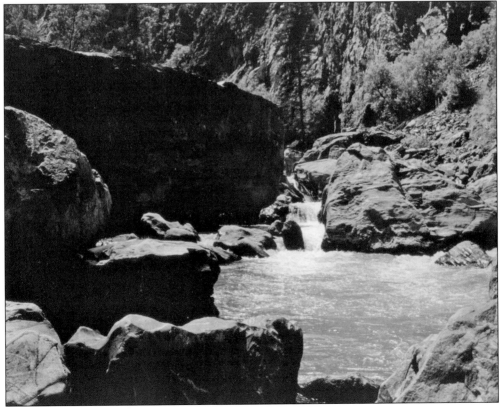

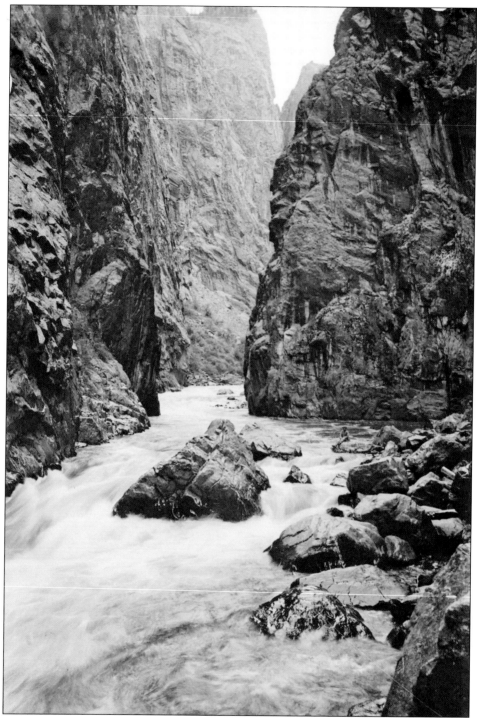

HIGH WATER AT THE NARROWS. Canyon walls close in and the Gunnison River drops dramatically at the Narrows in the Black Canyon. On June 15, 1921, nineteen thousand cubic feet of water per second roared through the canyon and Narrows. Today one can see the ring on the canyon walls showing how high waters traditionally were at this site in the canyon.

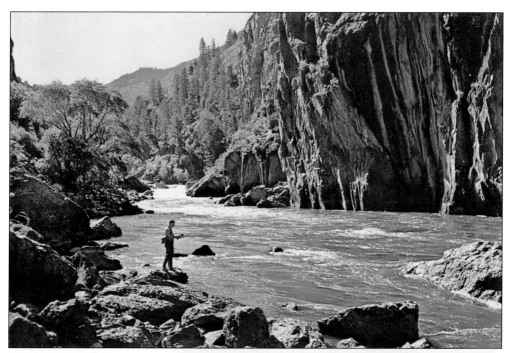

FISHING IN THE BLACK CANYON. The Gunnison River is one of the finest trout streams in the world, and its inaccessibility greatly limits the number of fishermen. Here an angler in the lower canyon tries his luck in the 1950s.

THE NARROWS. The walls of the Black Canyon narrow to 44 feet in this dangerous section of the gorge. There is no shoreline on either side and the Gunnison River drops dramatically. There is no going back here—one is committed to head downstream.

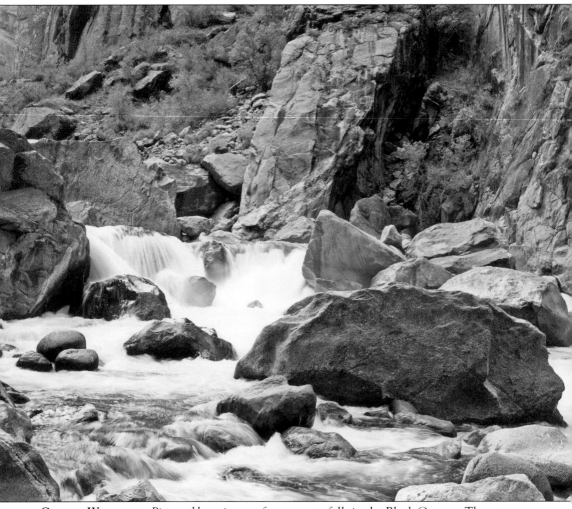

CANYON WATERFALL. Pictured here is one of many waterfalls in the Black Canyon. The presence of huge rocks, which have tumbled off the canyon's walls throughout centuries, have made the Gunnison River a very treacherous place for hiking or boating.

Two

THE PELTON PARTY

LANDOWNER JOHN PELTON. During the fall of 1900, John Pelton (center), a wealthy landowner in the Uncompahgre Valley, equipped a party to explore the Black Canyon of the Gunnison River and to see the "lay of the land." Pelton had an economic stake in this trip. If he could find a tunnel site in the canyon that would bring Gunnison River water to the Uncompahgre Valley his land would greatly increase in value. With Pelton on the expedition were J. A. Curtis, M. F. Hovey, E. B. Anderson, and William W. Torrence. The men took two wooden boats, each weighing approximately 300 pounds, and sufficient supplies for 30 days.

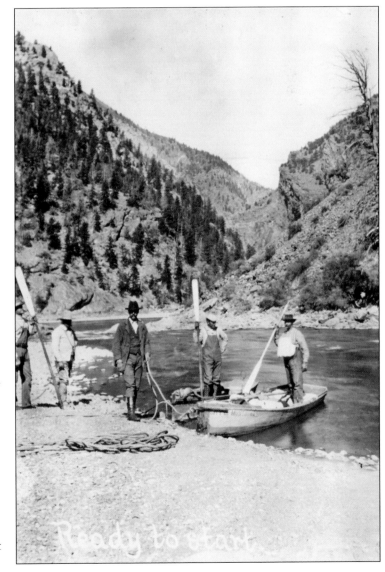

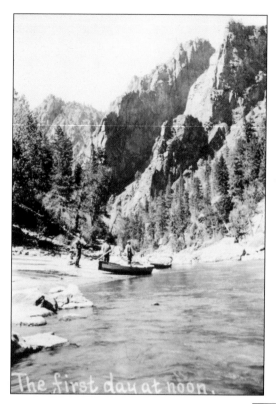

The first day at noon.

EARLY. The Pelton party put into the Gunnison River at the little village of Cimarron. At noon of the first day optimism was high. However, the men were in the canyon for 21 days and only covered 14 miles. One boat was lost early in the journey with half the supplies. At the end of the 14 miles, the Pelton party came to a section of the canyon where the Gunnison River roared through perpendicular walls and neared a great waterfall; no one could tell what lay ahead. Battered and exhausted, the men gave up their effort at the "Falls of Sorrow" but were lucky enough to be able to climb the rugged canyon wall, coming out on the north rim. The expedition was a failure.

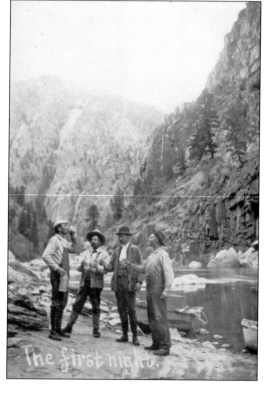

The first night.

THE FIRST NIGHT. John Pelton, second from the right, celebrates his first night in the Black Canyon with three of the four men in the party. The wooden boats had carried the men safely through the initial stage of the canyon, but tremendous danger in the wild gorge awaited them.

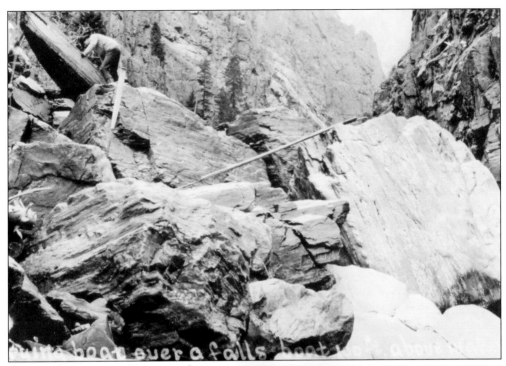

...ing boat over a falls boat ...'d above...

CANYON CHALLENGES. Here one of the Pelton party is attempting to drag a 300-pound wooden boat over huge boulders in the Black Canyon. This was very difficult, backbreaking work, and it never stopped. The men soon realized it had been a mistake to take such boats into the canyon.

WHERE THE WATER DISAPPEARS. Here the Gunnison River was clogged by gigantic boulders that had broken off from the canyon walls. Attempting to carry both of the 300-pound boats over these rocks was difficult, time consuming, and ultimately impossible. John Felton now stared failure in the eyes.

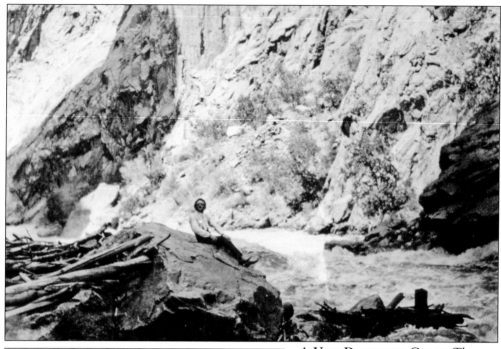

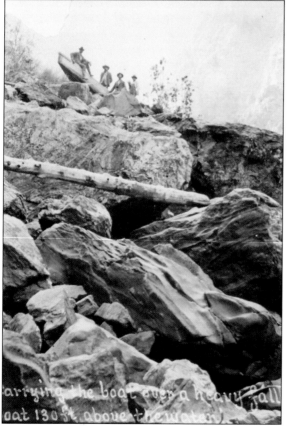

A Very Dangerous Gorge. The danger of the Black Canyon is seen here in 1900. Sitting on top of a huge rock, one member of the Pelton party gazes on the second-fastest falling river in the United States, 2,700-foot vertical walls, and rock and driftwood lining the shore. He is also aware of the fact that he and the four others in the party are among the very few to get this far in the canyon.

Boat Portage. This picture, taken by one of the Pelton party, reads, "Carrying the boat over a heavy falls—130 ft. above the water." Carrying two very heavy boats above the Gunnison River along Black Canyon ledges soon sapped the strength and resolve of the Pelton party. Three quarters of a mile in a day was considered good progress.

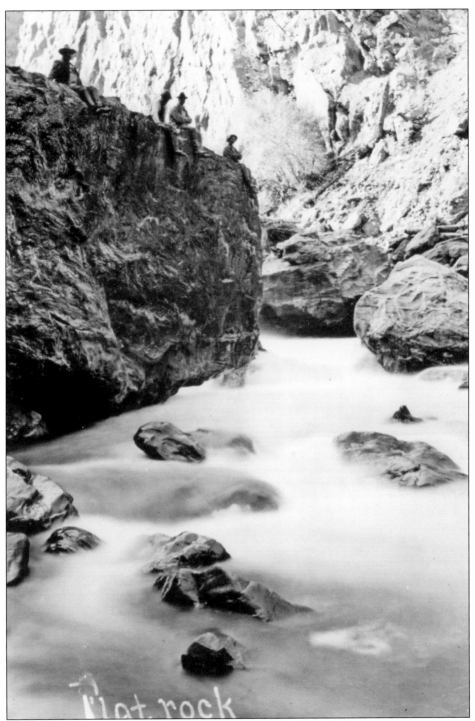

BLACK CANYON BECOMES MORE DANGEROUS. Four men from the Pelton party sit on a tremendous boulder in the Gunnison River. The water below them is a series of foaming rapids. This photograph shows the impossibility of using the boats to run the Gunnison River.

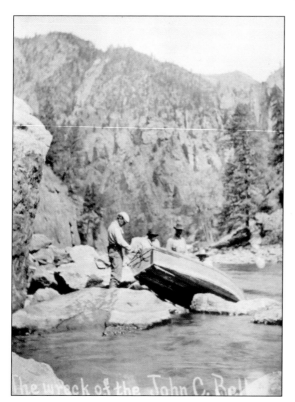

THE WRECK OF THE JOHN C. BELL.
Four members of the Pelton party gaze upon the wreck of one of their two boats. It was miraculous the party got as far as it did in the canyon with the huge and heavy structures. The Gunnison River was too violent for the boats, and they were nearly impossible to transport overland amidst gigantic rocks.

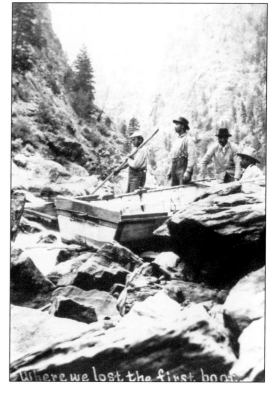

WHERE THE FIRST BOAT WAS LOST. Early in the Pelton journey into the Black Canyon, one of the two boats—the *John C. Bell*—was smashed among the rocks. Half of the party's supplies were lost, compromising the expedition. The loss of the *John C. Bell* had a silver lining though—now the party only had to struggle with one boat.

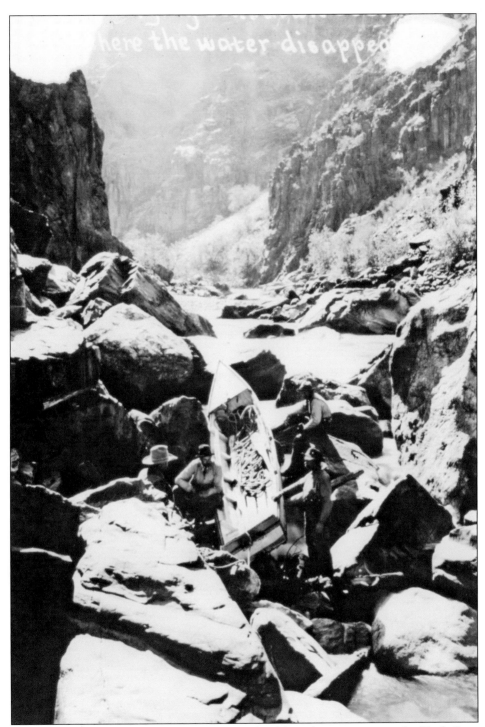

CARRYING THE BOAT OVER THE RAPIDS. The perils of the Pelton voyage into the Black Canyon are seen in this boat portage. With the Gunnison River gnashing its teeth below and preventing any passage by water, Pelton and his crew were forced to carry their two heavy boats over the rocks and boulders above the river. The going was very slow.

CHECKING BLACK CANYON WALLS.
By the third day in the Black
Canyon, the Pelton party began to
realize it might not succeed in its
efforts to find a tunnel site. The
canyon, with its vertical walls, fast-
flowing Gunnison River, and huge
boulders, had taken a toll on the
men. They began to examine the
canyon walls for places to get out.

PELTON EXPEDITION. Members
of the John Pelton expedition
carry one of their two 300-pound
boats over huge rocks in the upper
reaches of the Black Canyon in
1900. The Gunnison River below
was far too dangerous to run.

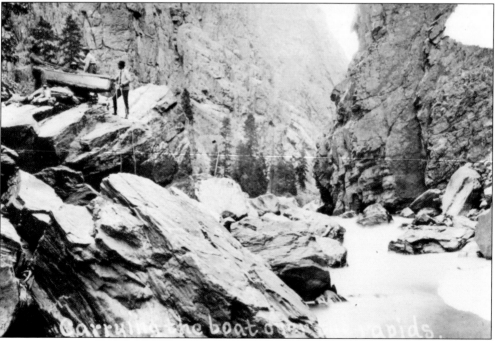

EXPLORING A CAVE. This is one of the few places on the Gunnison River where the Pelton party was able to use a boat. Here one of the crew paddles the *City of Montrose* while John Pelton watches. En route, the men explored a small cave used by animals in the canyon.

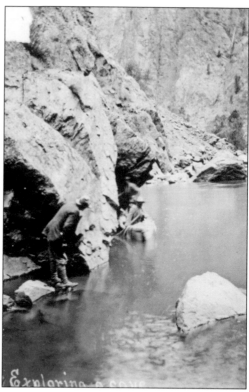

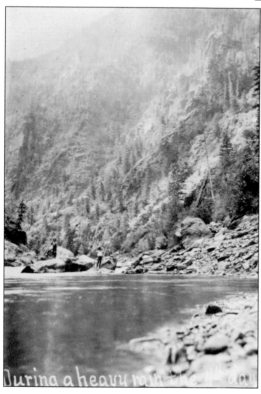

DURING A HEAVY RAIN ON THE FOURTH DAY. The Pelton party was hit with a heavy rain on their fourth day in the Black Canyon, raising the Gunnison River and making all party members miserable. The torrential downpour forced the party to halt its journey because of very slick rocks that they were unable to navigate safely.

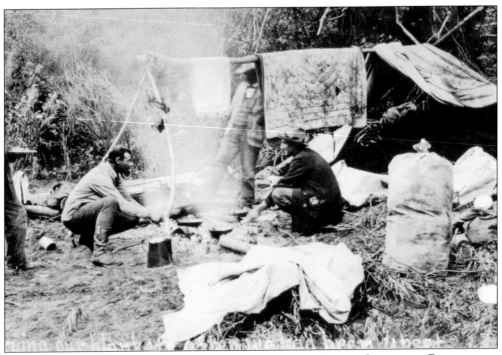

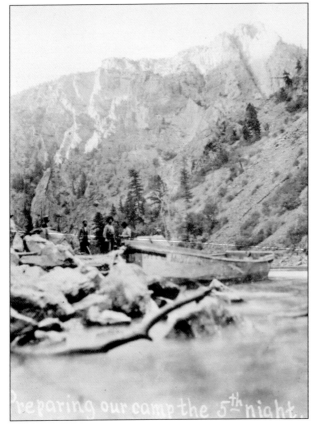

DRYING OUT IN THE BLACK CANYON. The John Pelton party is seen drying out after losing one of their wooden boats in the Black Canyon in 1900. Pelton made the first attempt to find a tunnel site to divert Gunnison River water out of the canyon.

PREPARING CAMP ON THE FIFTH NIGHT. Now deep into the Black Canyon, John Pelton and his crew of four prepare to make camp late in the afternoon of the fifth day in the gorge. This picture shows the huge size of one of their boats, which they rarely got to put into the Gunnison River. Good campsites were hard to find in the canyon but when found were very much welcomed.

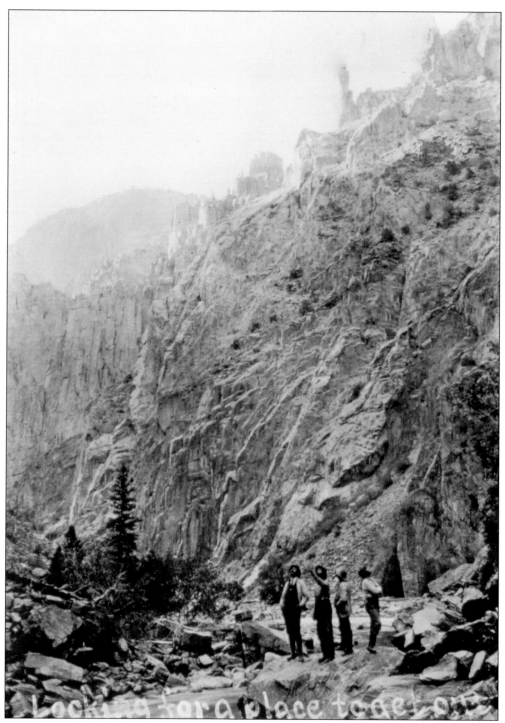

LOOKING FOR A PLACE TO GET OUT. Twenty-one days and 14 miles into the Black Canyon, the Pelton party was finished. One boat with half of their supplies had been lost, and they had come to a spot where the Gunnison River raged through the perpendicular walls and no one could tell what was ahead.

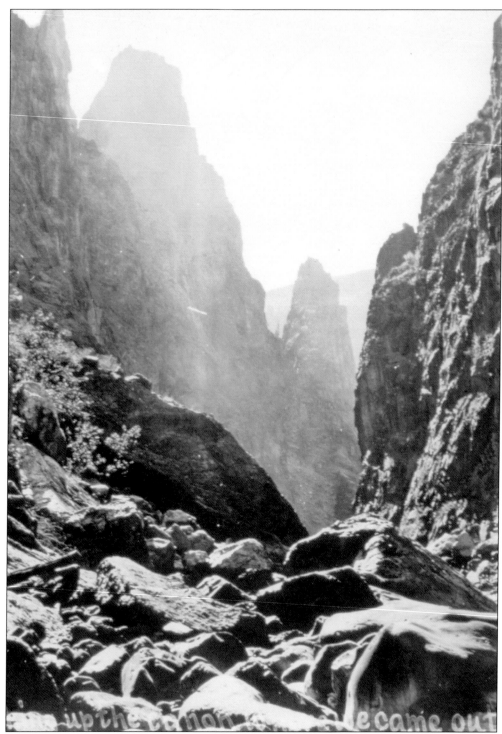

ESCAPE PASSAGE. In this rugged section of the Black Canyon, John Pelton made the decision to end his trip. He had no options; the battered men with him had had enough. The Black Canyon had won its battle against the mere mortals trying to pass through it.

Abandonment Point: 2,500-Foot Cliff. After 21 days in the Black Canyon, the Pelton party came to a major waterfall—the Falls of Sorrow. With no knowledge of what really lay ahead, it was here they gave up and prayed they would be able to climb the rugged canyon cliffs to get out.

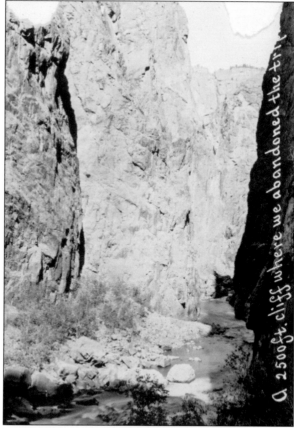

A 2500 ft. cliff where we abandoned the tr...

Last Bed in the Canyon. On their 20th night in the Black Canyon, the Pelton party bedded down for the night. They had been savaged in the wild gorge and were almost out of supplies. The following morning they hoped to be able to climb the near vertical canyon walls and escape its clutches.

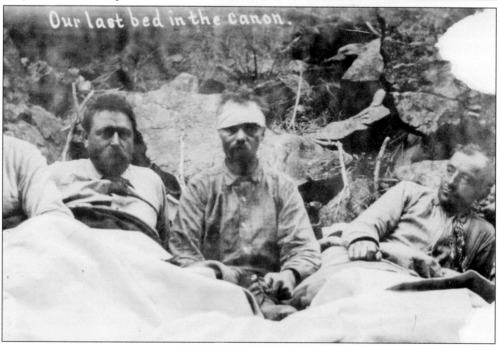

Our last bed in the canon.

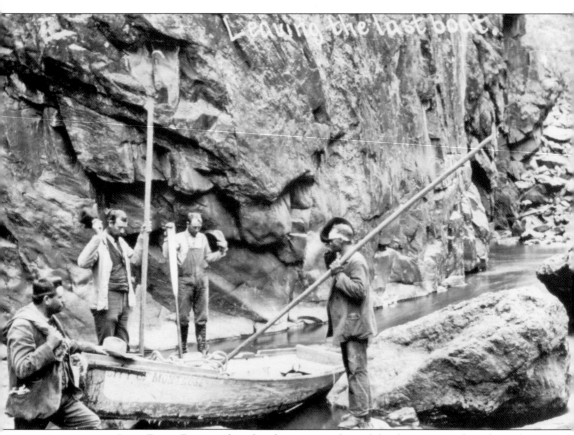

LEAVING THE LAST BOAT. Bowing their heads in prayer, four of the five men in the John Pelton party admit defeat in the Black Canyon after 21 days of a harrowing voyage. The party spent a day climbing out of the canyon, coming out on the north rim nearly 100 miles by surface travel from their homes.

Three

FELLOWS AND TORRENCE I

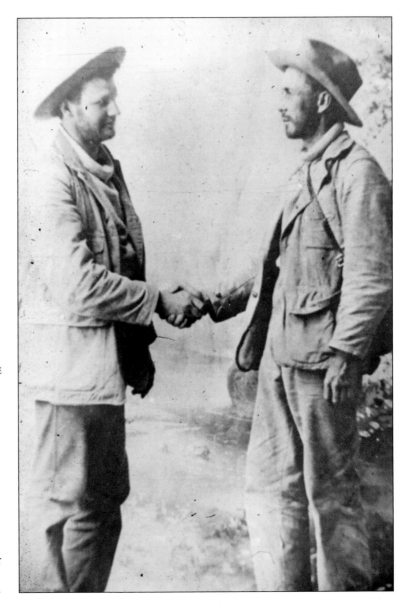

WILLIAM TORRENCE AND ABRAHAM FELLOWS. The two heroes of the Black Canyon shake hands after the completion of their great journey of 1901. Torrence, on the left, was a Montrose native and 29 years old at the time. Fellows was a civil engineer with a Yale degree and was 37 in 1901.

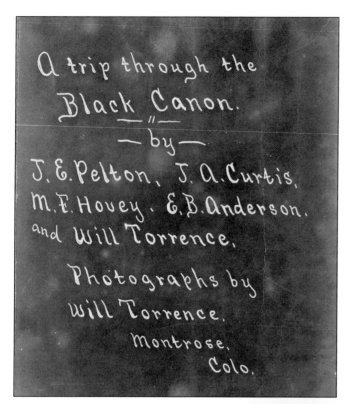

A trip through the
Black Canon.
—"—
—by—
J. E. Pelton, J. A. Curtis,
M. F. Hovey, E. B. Anderson,
and Will Torrence,

Photographs by
Will Torrence,
Montrose,
Colo.

PELTON JOURNAL. After returning from their ill-fated journey in the Black Canyon in 1901, the members of the Pelton party wrote of their trials and tribulations in the gorge. William Torrence, who took most of the pictures on that trip, used his experience as a member of the Pelton party to avoid making the same mistakes when he accompanied Abraham Fellows into the canyon the following year.

Home sweet home

WILLIAM TORRENCE. After his 1900 trip in the Black Canyon, William Torrence poses for a picture in his hometown of Montrose. Torrence was then 28 years old and a superb athlete. He was an excellent mountain climber and swimmer and in superb physical condition—traits that would serve him well on his second canyon trip in 1901.

CAMP ON VERNAL MESA. In June 1901, two months before his Black Canyon survey, Abraham Fellows established a camp on Vernal Mesa above the gorge. He spent two months there conducting a reconnaissance survey. He declared, "I never lost an opportunity to study the canyon from the top and of finding ways of getting down to it."

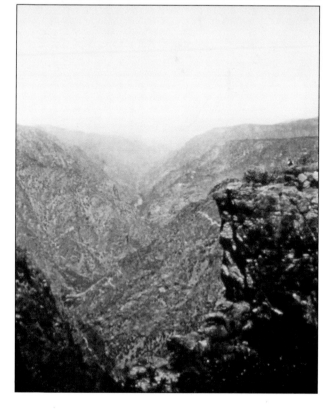

CANYON FROM VERNAL MESA. Taken on July 21, 1901, this picture shows Abraham Fellows on top of a rock on Vernal Mesa. He was looking for possible escape routes from the Black Canyon should he be unable to continue going through the gorge. The picture was taken only 22 days before he entered the canyon.

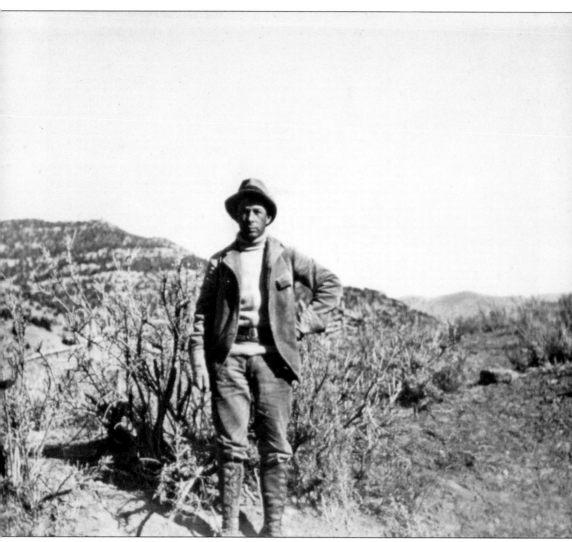

ABRAHAM LINCOLN FELLOWS, 1901. Abraham Fellows is on top of Vernal Mesa one month before his Black Canyon trip in August. Fellows spent two months surveying the Black Canyon from this vantage point. He often rode his horse, Apache, 100 miles a day and had gotten to know the mesa and canyon better than anyone else previously.

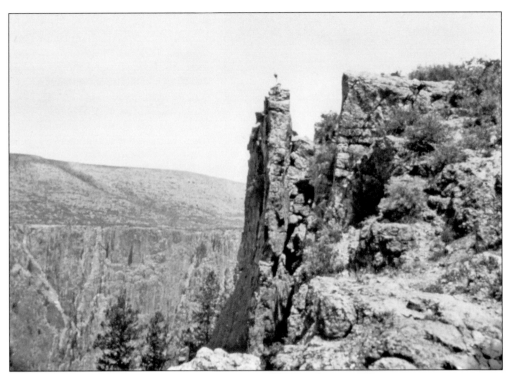

LOOKING OVER THE BLACK CANYON. Abraham Fellows is perched on top of a pinnacle examining the Black Canyon for possible escape routes before his daring August 1901 trip. Fellows spent June and July in preliminary surveying.

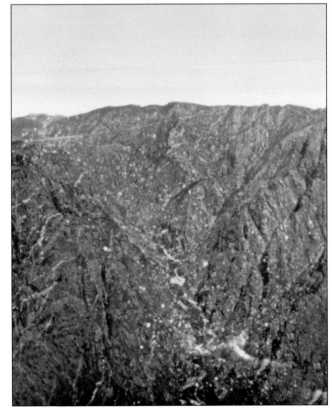

"OMINOUS AND FOREBODING GORGE." These are the words of Abraham Fellows as he viewed the Black Canyon from the top of Vernal Mesa in 1901. Fellows was aware of the danger of his upcoming trip. He declared that "the prophecy heard from all sources was that I would be killed if I undertook the trip."

ROCKFALL IN THE CANYON. One of the hazards faced by Abraham Fellows and William Torrence in the canyon was rockfalls. Fellows stated, "Occasionally a rock would fall from one side or the other with a roar and crash, exploding like a ton of dynamite when it struck bottom, making us think our last day had come."

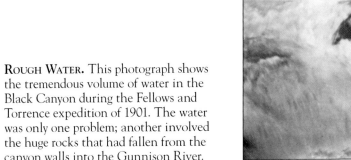

ROUGH WATER. This photograph shows the tremendous volume of water in the Black Canyon during the Fellows and Torrence expedition of 1901. The water was only one problem; another involved the huge rocks that had fallen from the canyon walls into the Gunnison River.

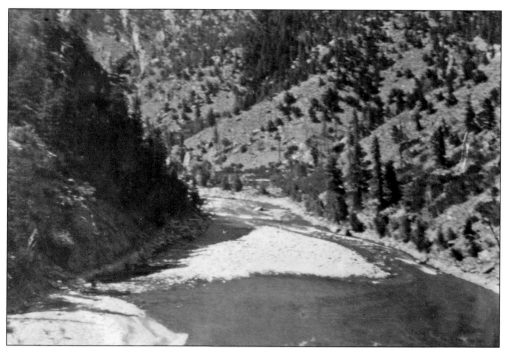

THE TRIP BEGINS. This is how the Black Canyon and Gunnison River looked on August 12, 1901, at 3:00 p.m. as Abraham Fellows and William Torrence began their epic trip. The two men took the train from Montrose to Cimarron and then walked to this spot. Fellows recalled, "A woman traveler [on the train] was heard to remark to her companion that she was glad the conductor had put those two tramps off."

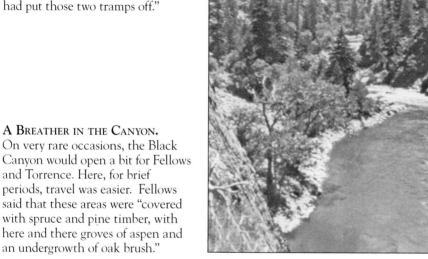

A BREATHER IN THE CANYON. On very rare occasions, the Black Canyon would open a bit for Fellows and Torrence. Here, for brief periods, travel was easier. Fellows said that these areas were "covered with spruce and pine timber, with here and there groves of aspen and an undergrowth of oak brush."

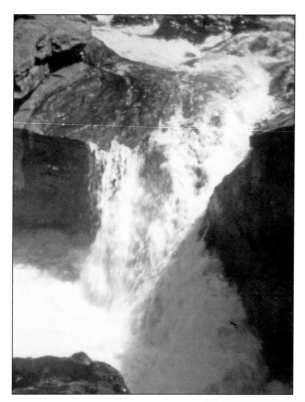

CANYON WATERFALL. This is one of many large waterfalls Fellows and Torrence were forced to navigate around. It was a 25-foot drop to the rocks below. Fellows called this drop, passed on the seventh day, one of the most dangerous in the canyon.

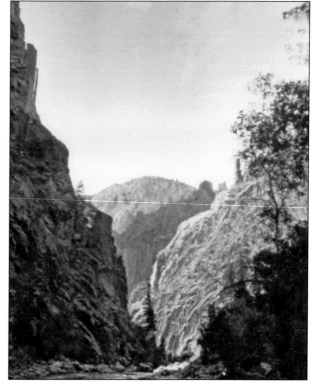

GIANT STAIRWAY. Abraham Fellows and William Torrence came to this point in the Black Canyon on the fifth day. Fellows, in awe, declared, "I called this the Giant Stairway. The walls looked almost as if cut into enormous steps by some titan of old, while statues, turrets and pinnacles adorned the rugged precipices on either side."

Four

FELLOWS AND TORRENCE II

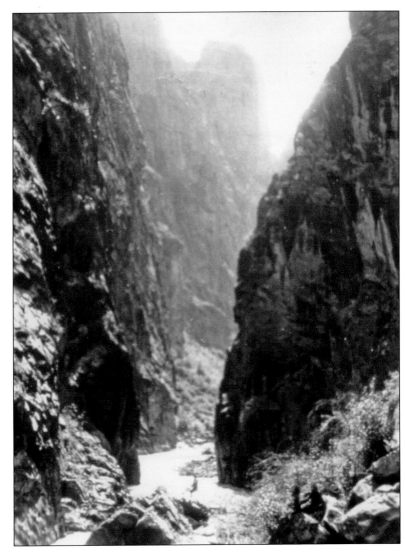

DEPTHS OF THE CANYON. This is how the Black Canyon looked to Abraham Fellows and William Torrence in 1901 as they went where no one had ever gone before. High cliffs, violent water, and no chance of going back awaited them. They faced terra incognita all the way through the canyon.

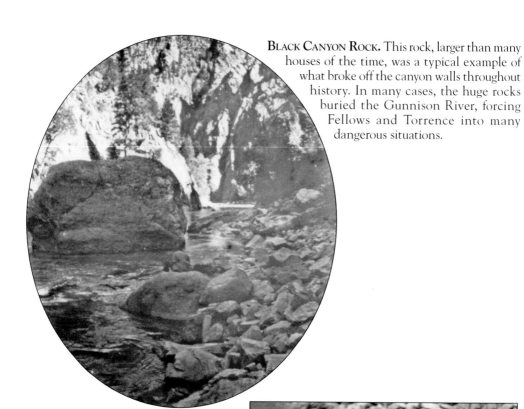

BLACK CANYON ROCK. This rock, larger than many houses of the time, was a typical example of what broke off the canyon walls throughout history. In many cases, the huge rocks buried the Gunnison River, forcing Fellows and Torrence into many dangerous situations.

REMAINS OF THE *JOHN C. BELL.* The Pelton party lost the *John C. Bell*, one of its two boats, in the Black Canyon during their 1900 trip. A year later, Abraham Fellows and William Torrence photographed the remains. They spotted bits and pieces of the boat over a 4-mile stretch of the canyon.

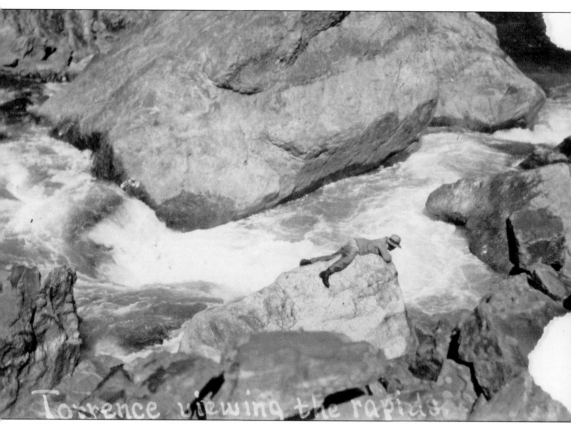

TORRENCE VIEWING THE RAPIDS. William Torrence is lying flat on a huge rock as he surveys a particularly nasty set of rapids in the Black Canyon. Torrence, who was a member of the ill-starred Pelton expedition of the previous year, learned that it was not advisable to take boats in the Black Canyon.

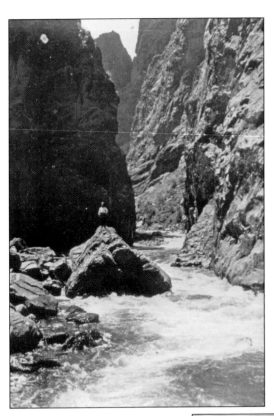

ROCKS IN THE BLACK CANYON. A huge rock has fallen into the Gunnison River. Here the canyon has narrowed and travel became very difficult. "At times," said Abraham Fellows, "the canyon would become so narrow that it would almost, but never quite, be possible to step across the river."

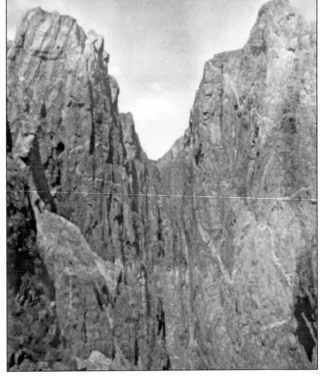

DEVIL'S SLIDE. Abraham Fellows named this famous wall as he approached it near the end of the fifth day in the Black Canyon. That night, Fellows and Torrence camped near the Devil's Slide at a spot they named Beaver Camp. Fellows stated that this came "from the fact that a colony of beaver had lived there and had cut down some of the great trees growing in the little flat which formed a delightful camping ground where we stopped for the night."

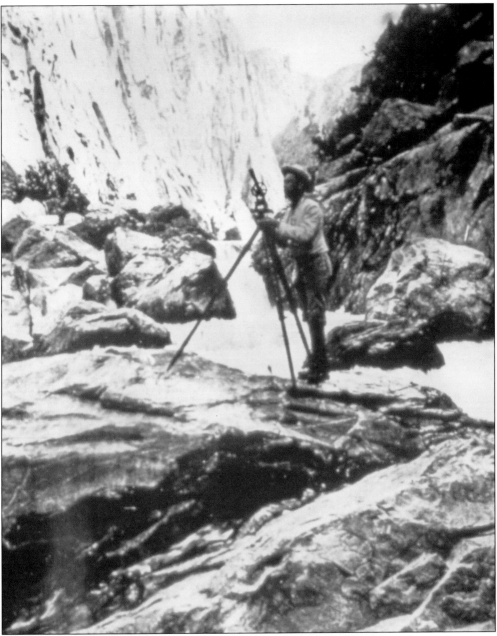

SURVEYING THE CANYON. Abraham Fellows has his instruments set up and is conducting his survey in a rugged section of the Black Canyon. Fellows commented on this picture taken by Torrence, "Working transit Point 44, looking up at the cliff top 2,600 feet above."

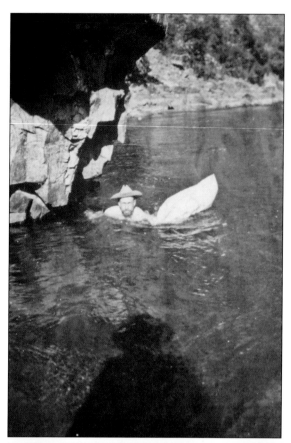

FELLOWS CROSSING. Abraham Fellows crosses from one side of the Gunnison River to another in the Black Canyon. He is carrying a rubber waterproof bag with survey instruments. Fellows and Torrence crossed the river 76 times on their 10-day journey. William Torrence took this picture and his shadow is visible at the bottom of the photograph.

"THE FLOAT." During one of many crossings of the Gunnison River in the Black Canyon, William Torrence is hidden behind an air mattress with survey instruments in a rubber bag on top. Despite the many river portages, the instruments and film carried by Torrence and Abraham Fellows stayed dry.

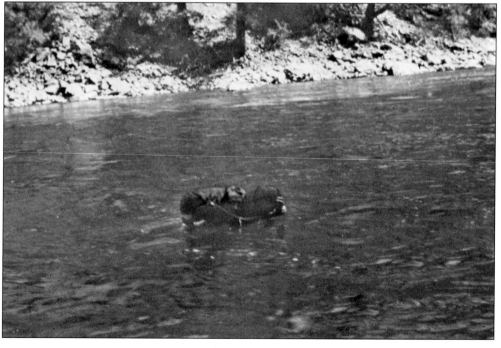

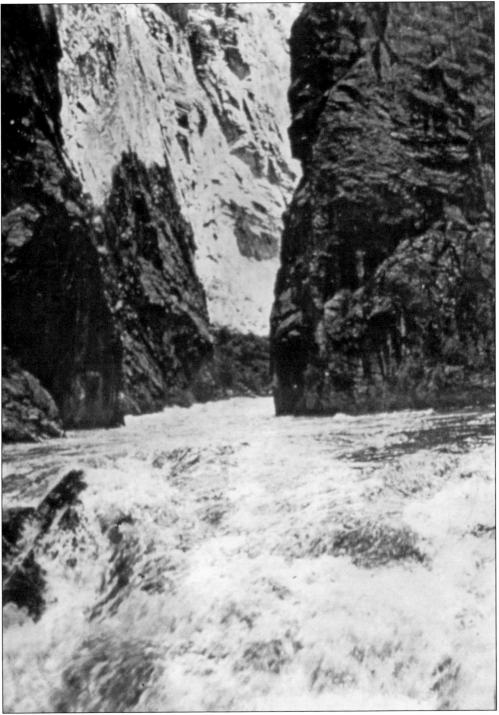

TURBULENT WATER. The difficulty of the Fellows and Torrence trip through the Black Canyon is seen here, with foaming and dangerous rapids and vertical canyon walls on both sides. To get through sections like these, the two explorers had two options, both of which were bad. They could try to run the dangerous water or climb nearly vertical cliffs to get around the rapids.

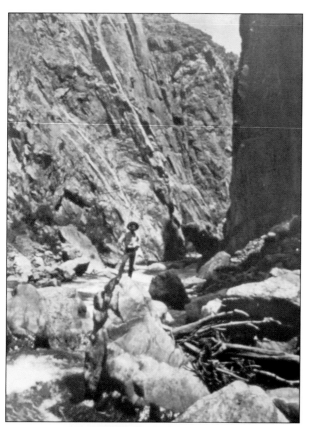

DOWNSTREAM IN THE BLACK CANYON. Abraham Fellows is looking down the Gunnison River on the second day of the epic journey of 1901. Fellows recalled, "Our surroundings were of the wildest possible description. The roar of the waterfalls was constantly in our ears and the walls of the canyon towering a half mile in height above us were seemingly vertical."

THE NARROWS. This section of the Black Canyon is fraught with danger. Located below the East Portal, the Narrows's canyon walls are only 44 feet from each other with no shore on either side. The canyon walls are vertical and over 2,000 feet high at this site.

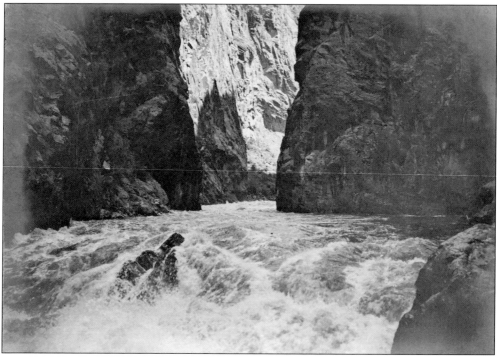

DRYING OUT. Abraham Fellows has clothes and boots off at the end of the third day in the Black Canyon, August 14, 1901. Asa Dillon, coming down by Trail Gulch, met Fellows and William Torrence here with more supplies. Both Fellows and Torrence remained here for two nights and a day, completely exhausted and Fellows stated to be "sleeping nearly all of the time."

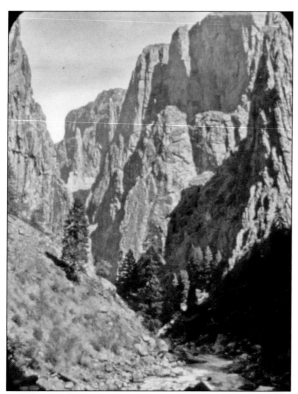

THE CANYON DEEPENS. As Fellows and Torrence worked their way deeper into the Black Canyon, the dangers grew. Fellows commented, "All walking was along boulders which formed the canyon walls. Easy walking was never to be found unless it was a very few feet upon some gravel bar. . . . Approaching a very dangerous point. No one had gone beyond here and survived."

INTO THE DEPTHS OF THE CANYON. On August 18, 1901, Abraham Fellows and William Torrence entered a particularly dangerous section of the Black Canyon. Gigantic boulders had fallen from the cliffs into the river and it took the two men six hours to traverse 300 yards. The water was treacherous and it was very difficult to get to either shore.

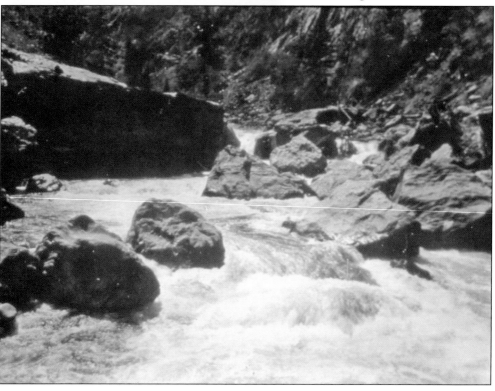

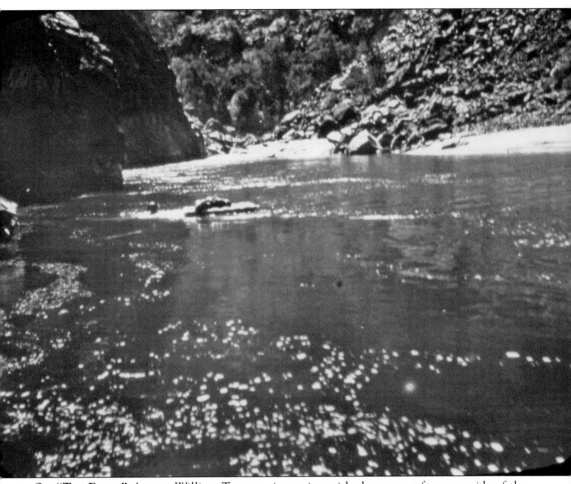

ON "THE FLOAT" AGAIN. William Torrence is moving with the current from one side of the Gunnison River to the other in August 1901. He is pushing an air mattress with survey instruments in a rubber bag on top of it. Fellows and Torrence crossed the Gunnison River continually during their 10-day exploration of the Black Canyon.

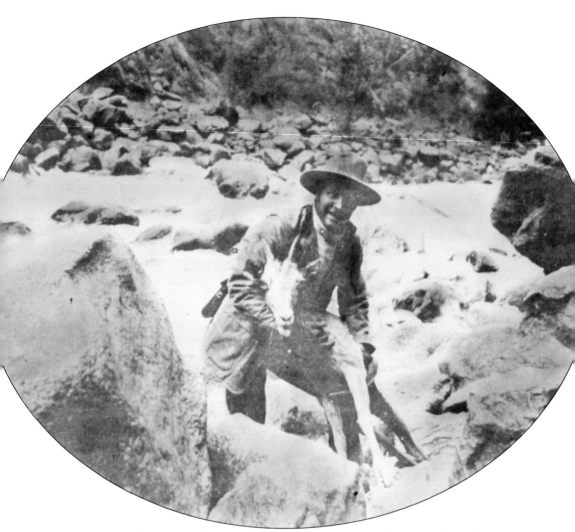

Torrence and a Mountain Sheep. On the seventh day of their exploration of the Black Canyon, Fellows and Torrence were out of food. Fellows stated, "We were hungry, sick, and exhausted, and were losing flesh." On this day, Fellows was climbing 40 feet above the river when he startled two sleeping mountain sheep. One jumped off the cliff and was killed. Fellows recalled, "Though the game laws of Colorado forbade . . . having a mountain sheep in possession . . . it was cooked and eaten."

Five

DENVER AND RIO GRANDE RAILROAD

BRYANT SURVEY TEAM IN THE CANYON. William Jackson Palmer, head of the Denver and Rio Grande, wanted to continue his railroad from Cimarron through the Black Canyon to where it ended near Lazear. In December 1882, Palmer's top surveyor, Bryon Bryant, led a 12-man party into the canyon expecting to make the entire journey in 20 days. Instead, 68 days passed before the five men who remained reached the canyon's end. Bryant told Palmer that a railroad in this section of the canyon was "impossible."

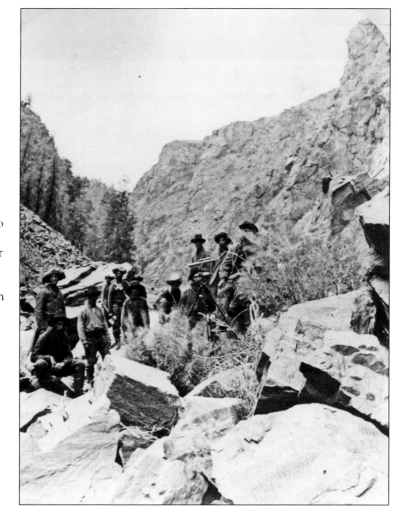

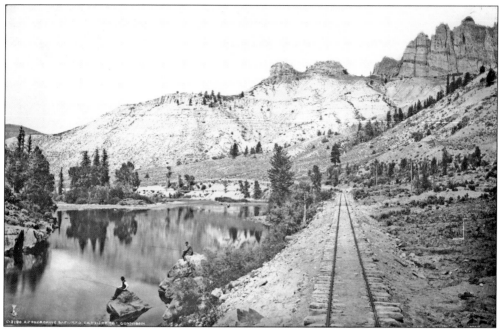

NEAR SAPINERO, 1880s. Two lone fishermen are trying their luck on the Gunnison River. They are fishing just outside of Sapinero near the beginning of the Black Canyon. Sapinero was named for a Ute chief.

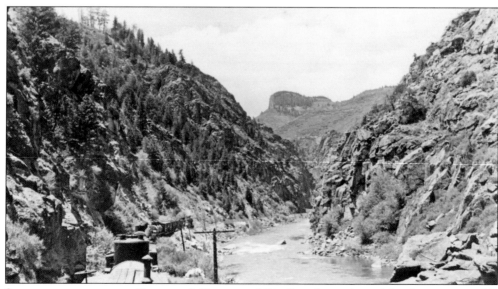

STEAMING THROUGH THE CANYON. A Denver and Rio Grande westbound freight train is visible as it navigates through the Black Canyon on June 6, 1940. The narrow-gauge railroad was always at risk, especially in winter and spring from snow, mud, or rock slides, which could easily knock trains into the Gunnison River.

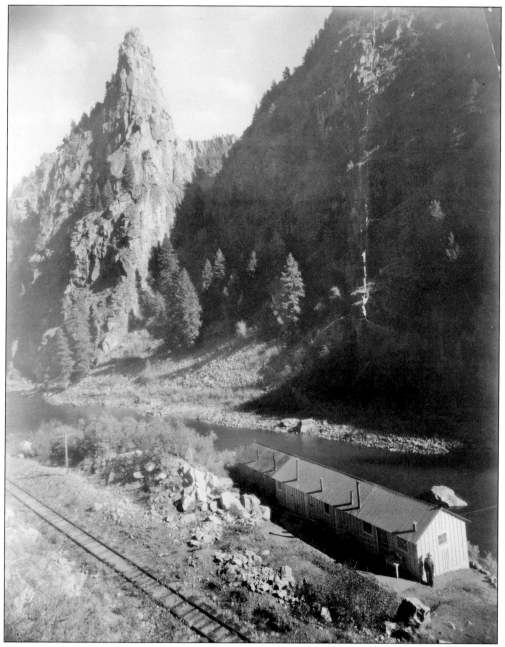

CURECANTI NEEDLE. Towering over 1,000 feet high in the Black Canyon between Sapinero and Cimarron, this majestic and isolated sentinel became the most famous landmark of the canyon. Below are Denver and Rio Grande tracks and a railroad section house.

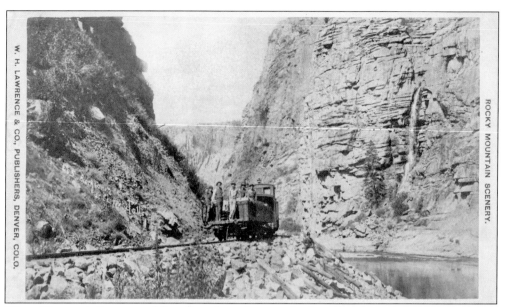

WORK TRAIN. A Denver and Rio Grande work train slowly makes its way through the Black Canyon with Chipeta Falls in view. The job of the work train was to precede the passenger or freight train, which would follow, checking for rock or mud slides or damaged tracks—all of which were common in the canyon.

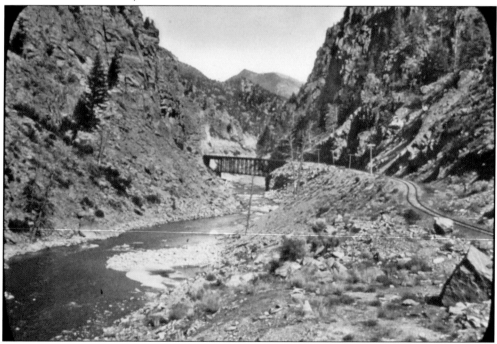

DENVER AND RIO GRANDE BRIDGE. The Denver and Rio Grande Railroad had to cross the Gunnison River many times along its 15-mile line from Sapinero to Cimarron. Much of William Jackson Palmer's surveying in this upper Black Canyon section had to be done from boats anchored by ropes. Many of the grading contractors who built the 15-mile line had also worked on Marshall Pass, which brought the railroad into the Gunnison Valley.

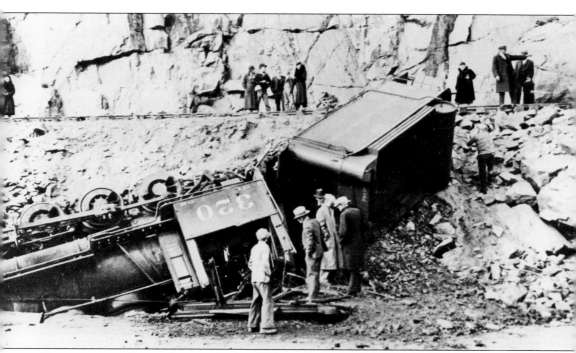

TRAGEDY IN THE BLACK CANYON. In the summer of 1934, this Denver and Rio Grande train was knocked off the tracks by a rock slide, and engineer "Sap" Richardson was killed in the wreck. The Black Canyon was always a dangerous place for the Rio Grande with rock slides, snowslides, and mud slides.

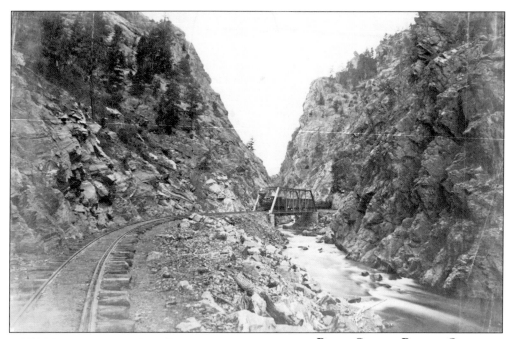

BLACK CANYON BRIDGE. One of the many Denver and Rio Grande bridges in the canyon, this one crosses a side stream. In this photograph, a train is crossing the bridge heading east. Rio Grande engineering in the canyon when the railroad was built in the 1880s was state of the art.

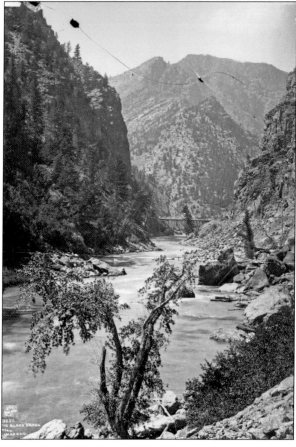

BLACK CANYON NEAR CIMARRON. The Denver and Rio Grande Railroad, after 15 miles in the Black Canyon, was forced to leave the gorge before continuing on to Montrose in 1882. A railroad bridge near Cimarron is visible in the center of the photograph. The railroad first reached Cimarron on August 9, 1882, when it was only a city of tents.

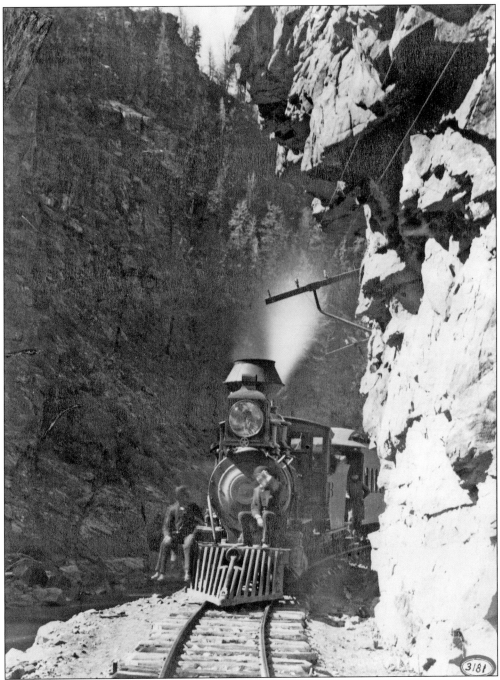

THE BOWELS OF THE CANYON. Denver and Rio Grande railroaders sit on the front engine as they have their picture taken. The Black Canyon was very narrow at this point, with very little room to maneuver. Meanwhile, the Gunnison River is gnashing its teeth below the tracks.

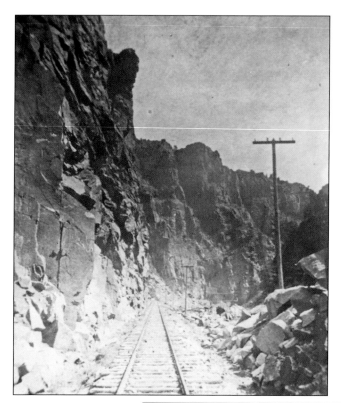

THE BLACK CANYON LINE.
Denver and Rio Grande
narrow-gauge tracks run
through the rugged Black
Canyon. Alongside of the
tracks is the telegraph line,
which followed the railroad
from Sapinero to Cimarron.
The canyon wall was very close
to the tracks, which was very
dangerous due to rockfalls.

**CRYSTAL CREEK
TRESTLE.** A Denver
and Rio Grande
trestle crosses
Crystal Creek in the
Black Canyon. The
photograph was taken
on June 6, 1940, and
is looking west down
the canyon. Crystal
Creek flowed into
the Gunnison River
between Sapinero
and Cimarron.

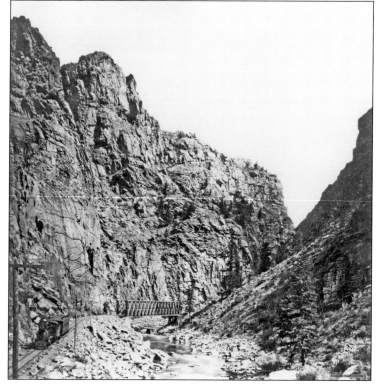

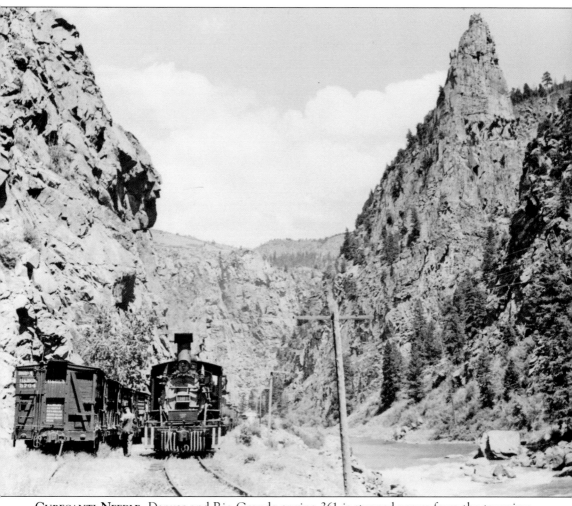

CURECANTI NEEDLE. Denver and Rio Grande engine 361 is stopped across from the towering Curecanti Needle in June 1940. Trains had run through Black Canyon for almost 60 years, but the end was near.

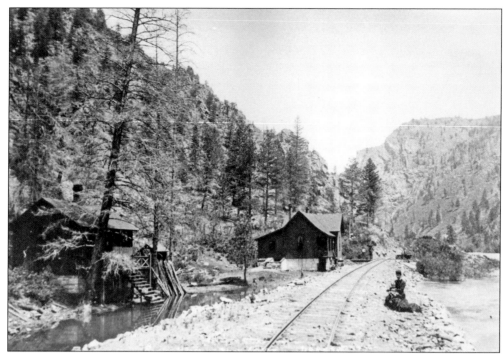

BLACK CANYON, 1886. A woman and her young child wait alongside the Denver and Rio Grande Railroad tracks for a train to arrive. A little cabin and a Rio Grande building are visible. Both were located not far from the famed Curecanti Needle in the Black Canyon.

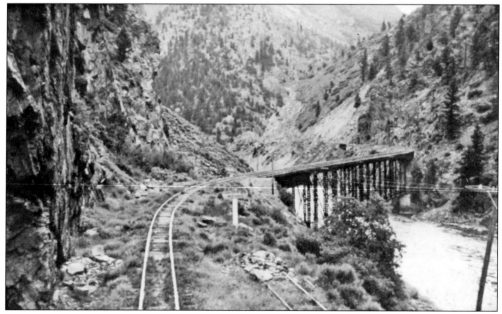

CROSSING THE RIVER. Here a Denver and Rio Grande bridge crosses the Gunnison River in the upper Black Canyon. Whenever the builders of the narrow-gauge line were "cliffed" out on one side of the Black Canyon, they were forced to cross to the other side where, hopefully, they had enough space to lay track.

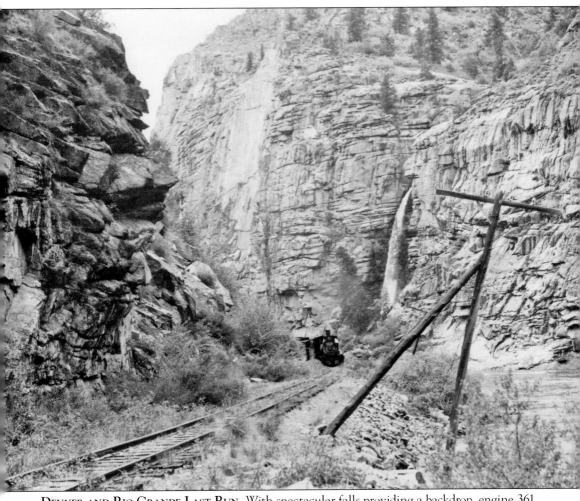

DENVER AND RIO GRANDE LAST RUN. With spectacular falls providing a backdrop, engine 361 of the Denver and Rio Grande makes its last run between Sapinero and Cimarron in the Black Canyon in 1954. An era had ended.

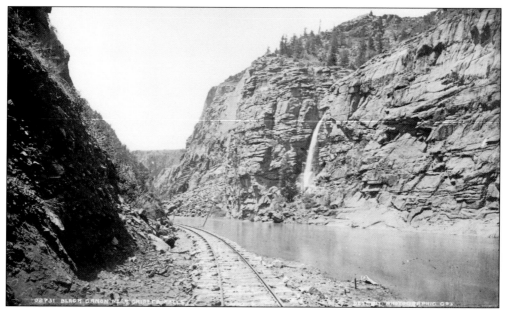

CHIPETA FALLS. Named for the second wife of the great Ute Indian chief Ouray, the falls drop into the Gunnison River in the Black Canyon between Sapinero and Cimarron. Below is the Denver and Rio Grande narrow-gauge railroad grade. Chipeta Falls became a major tourist attraction for the railroad.

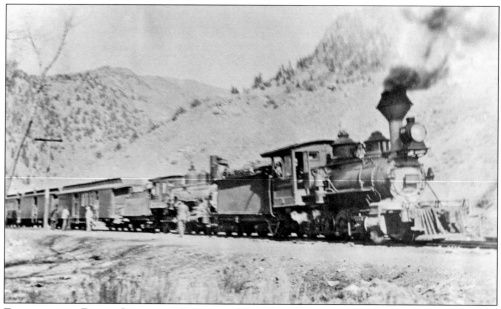

ENTERING THE BLACK CANYON. A Denver and Rio Grande train enters the Black Canyon in the 1920s. Walls in the upper part of the canyon, near Sapinero, were 500 feet high, and they became higher as the Rio Grande steamed towards Cimarron, 15 miles down the Gunnison River. This stretch of track was among the most scenic in the nation.

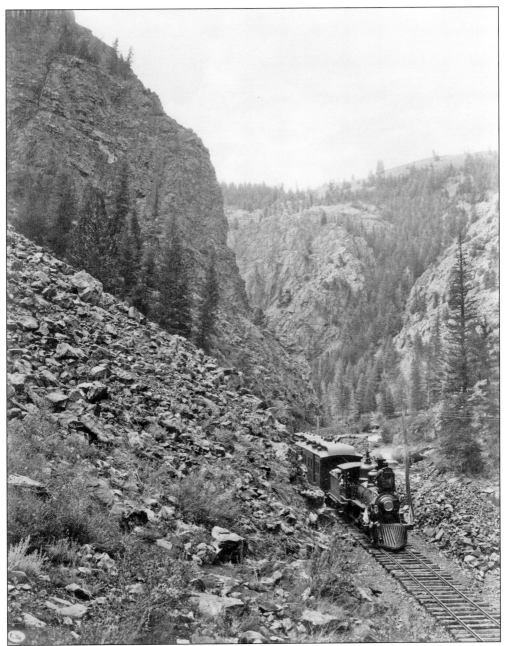

THE NARROWS OF THE LAKE FORK. The Lake Fork of the Gunnison River heads at 12,600 feet near Cinnamon Pass, deep in the San Juan Mountains. In 1889, the Denver and Rio Grande Railroad ran a 37-mile branch line from Lake City to Sapinero. This photograph shows a Rio Grande train running through the rugged Lake Fork Canyon above Sapinero and the Black Canyon.

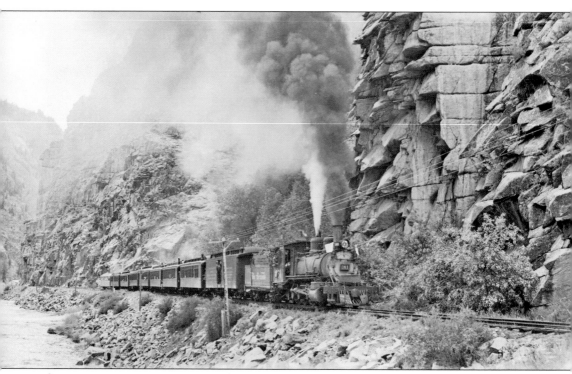

STEAMING THROUGH. A Denver and Rio Grande train steams through the Black Canyon before the beginning of the 20th century. Billing itself as the "biggest little railroad in the world," the Rio Grande used the Black Canyon as part of its main line during its early years of operation.

NARROW-GAUGE TRACKS.
The Denver and Rio Grande
Railroad was able to run
in the upper Black Canyon
between Sapinero and
Cimarron. Beyond Cimarron,
laying track was impossible.
A traveler in 1908 declared,
"Beyond the mouth of the
Cimarron . . . the Gunnison
River pushes through the
mighty cleft between Blue
and Vernal Mesas, the gorge
becoming deeper and the
cliffs more precipitous with
each succeeding mile."

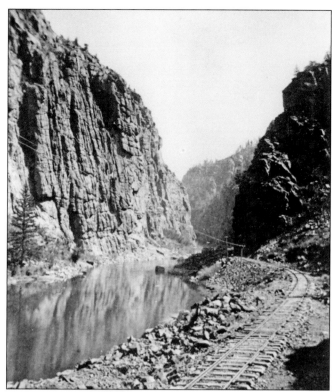

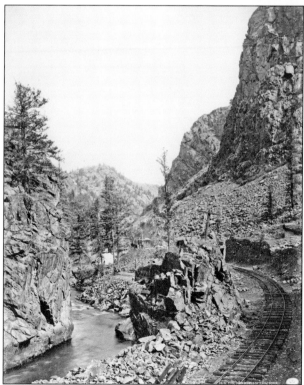

LAKE CITY BRANCH, D&RG.
The Lake Fork Canyon was a
rugged and vicious gorge that
ran into the Black Canyon
near Sapinero. The Rio Grande
built a branch line from Lake
City to Sapinero hoping to tap
a new and great silver and gold
camp. Alas, Lake City did not
prove to have great ore, and
the branch line floundered.

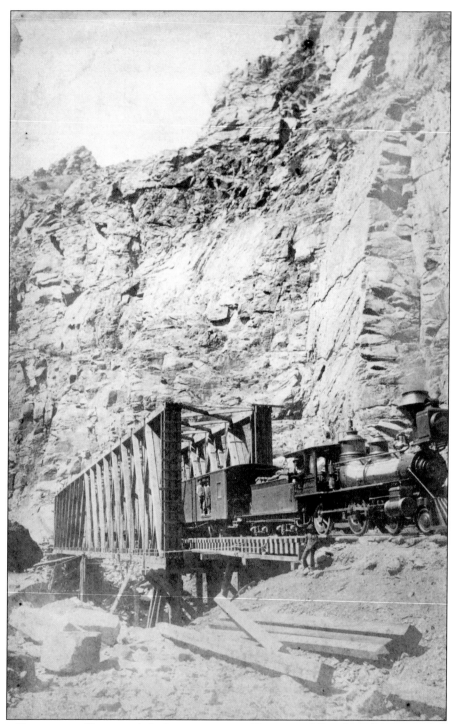

EARLY RUN IN THE CANYON. A little narrow-gauge Denver and Rio Grande engine makes its way slowly across a just-built bridge in the Black Canyon in the early 1880s. The little narrow-gauge engines were perfectly suited for mountain passes, narrow canyons, and the rough terrain of the West.

Six

TOWNS NO MORE

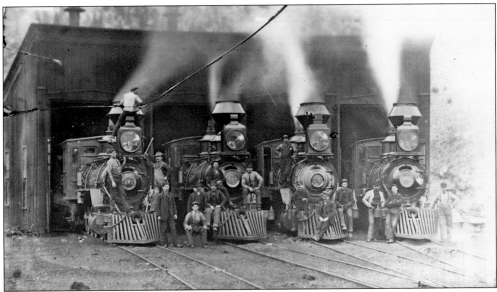

NARROW-GAUGE ENGINES AT CIMARRON, 1884. Located 45 miles west of Gunnison and 20 miles east of Montrose, Cimarron was where the Denver and Rio Grande Railroad climbed out of the Black Canyon and headed west over Cierro Summit. Cimarron was home to 250 residents and the Black Canyon Hotel, which served hunters and fishermen. The Denver and Rio Grande maintained the roundhouse and repair shops (pictured) there.

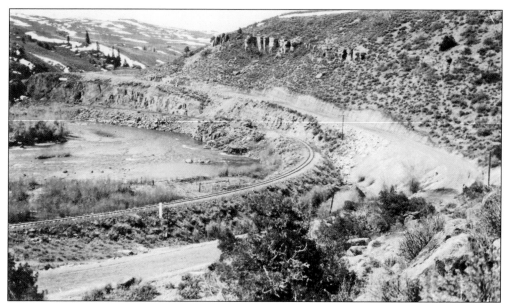

D&RG LINE. Taken in 1911, this shows the Denver and Rio Grande narrow-gauge railroad tracks between Cebolla and Sapinero, west of Gunnison. Above is the dirt automobile road, which was impassible in the winter. The Blue Mesa Reservoir now dominates this region.

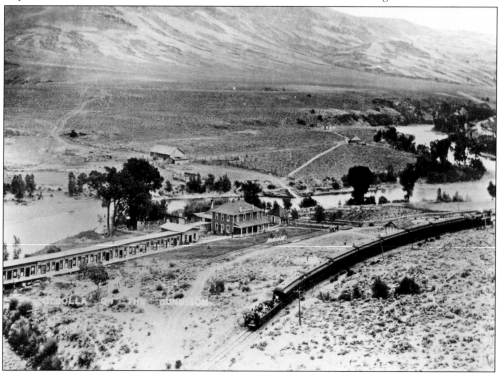

SPORTSMAN'S LODGE AT CEBOLLA. Beautiful Sportsman's Lodge was built in 1888, and soon after, J. J. Carpenter built a long row of cabins for the hunters, fishermen, and weary tourists arriving by rail. The lodge was built on the Gunnison River with the Denver and Rio Grande Railroad tracks nearby.

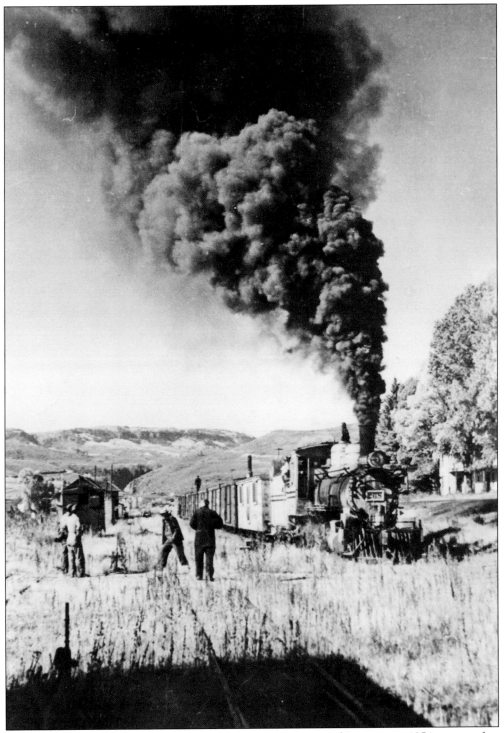

LAST RUN. A Denver and Rio Grande train makes its way out of Sapinero in 1954 on one of its last runs in the Gunnison country. Soon Sapinero would be buried under 300 feet of water in the Blue Mesa Reservoir following the construction of the Blue Mesa Dam in the 1960s.

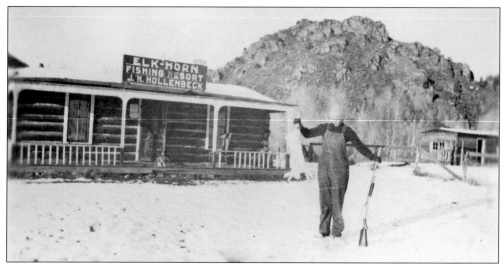

THE ELKHORN RESORT. This resort was located 10 miles west of Gunnison along the Gunnison River and was flooded by the Blue Mesa Reservoir. The Elkhorn was a very popular fishing and hunting resort. In this photograph, a local hunter shows off his take for the day—a jackrabbit.

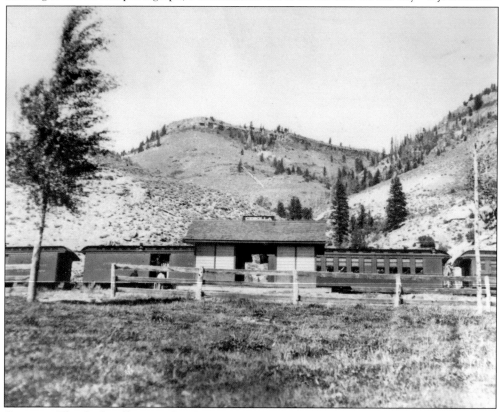

CEBOLLA. This little village on the Gunnison River, 16 miles west of Gunnison, was once an end-of-track on the Denver and Rio Grande Railroad. Later rancher J. J. Carpenter turned it into a resort for hunters and fishermen. Like nearby Iola and Sapinero, it was flooded by the Blue Mesa Reservoir in the 1960s.

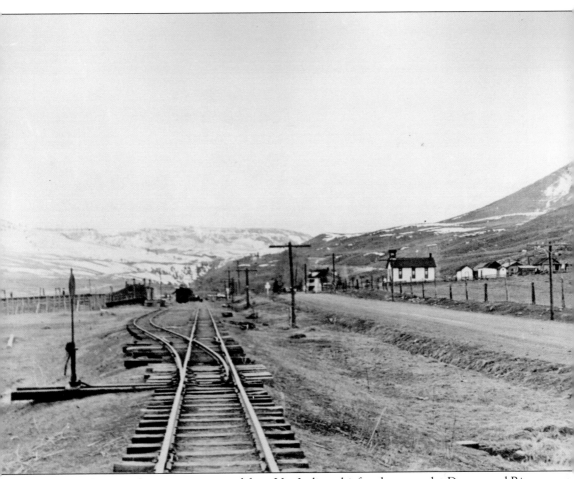

SAPINERO SCHOOL. Sapinero was named for a Ute Indian chief and was on the Denver and Rio Grande Railroad's main line. The famous one-room schoolhouse is seen on the right, and Rio Grande tracks are on the left. The school began in a rented cabin in 1890. Every spring when the teacher unlocked the door to begin school, she found to her dismay that rats and mice had taken over.

DENVER AND RIO GRANDE NEAR CEBOLLA. This Denver and Rio Grande engine is steaming along near Cebolla, only 15 years before Blue Mesa Reservoir waters would inundate the village. Cebolla received its Spanish name from the abundance of wild onions growing along Cebolla Creek.

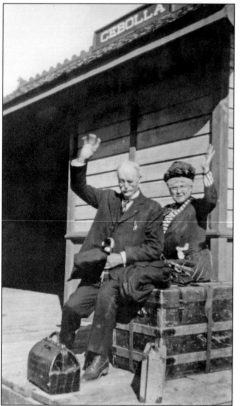

WAITING FOR THE TRAIN. Toby and Mary Ames wait for the Denver and Rio Grande passenger train at Cebolla in 1921. Cebolla was perfectly located for ranching, hunting, fishing, and tourism. It was located on the Gunnison River, 16 miles west of Gunnison.

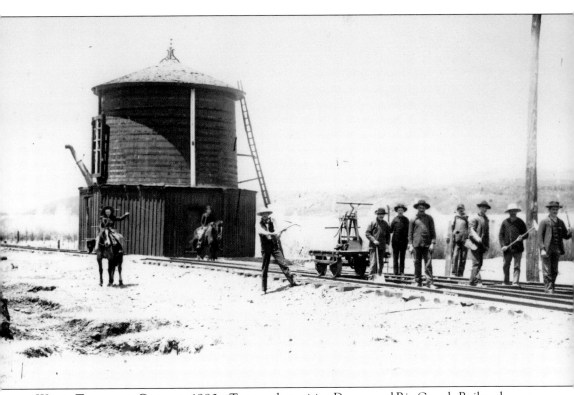

WATER TANK NEAR CEBOLLA, 1880s. Two ranchers visit a Denver and Rio Grande Railroad crew working on tracks near Cebolla not long after the railroad laid tracks there. Many of the workers were Italian immigrants hoping to improve their lot in life.

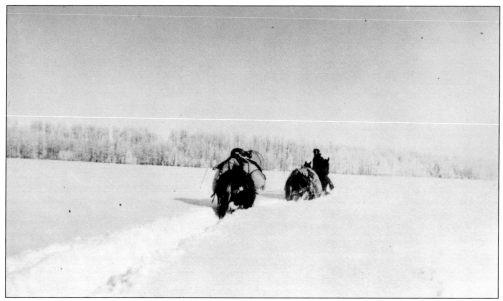

PACKING IN WINTER SUPPLIES. Rancher Craig Goodwin packs in supplies through heavy snow over Black Mesa to his ranch near Crawford in February 1927. Back Mesa is a spectacular area just east of the Black Canyon.

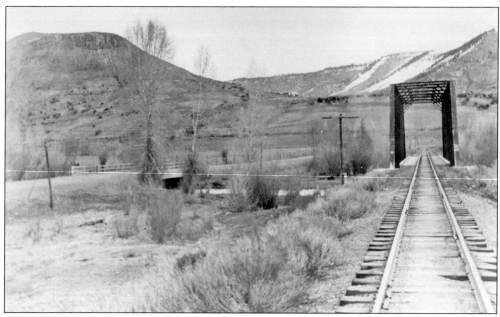

DENVER AND RIO GRANDE BRIDGE. The narrow-gauge railroad crossed Soap Creek near Sapinero not far from the beginning of Black Canyon. The dirt automobile road is seen on the left. Sapinero's original name was Soap Creek and it began in 1881 as a Denver and Rio Grande end-of-track.

SAPINERO, 1930S. Sapinero was where the Black Canyon began. The village had two hotels, a mercantile store, a school, a post office, and a large freight office. It was a central meeting place for ranchers, railroaders, sportsmen, and tourists. Today it is 300 feet below the waters of the Blue Mesa Reservoir.

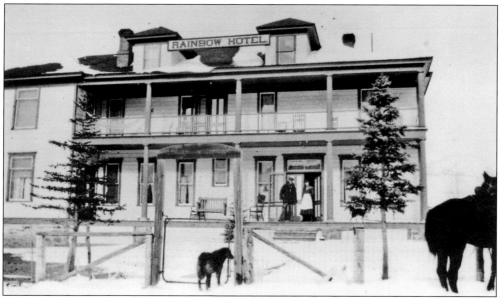

RAINBOW HOTEL, SAPINERO. Sapinero had two hotels in the beginning—the Metropolitan and the Sapinero. The Sapinero burned down shortly after the beginning of the 20th century and was replaced by the Rainbow Hotel. Both housed railroad workers and tourists who came in on the Denver and Rio Grande Railroad. Sapinero was a great location for fishermen because of its easy access to the famed Gunnison River in the Black Canyon.

Railroad Crossing. A chicken crosses the Denver and Rio Grande tracks in Sapinero in 1916. Sapinero controlled the entrance to the Black Canyon and two great mesas—the Blue and Black—which towered nearby.

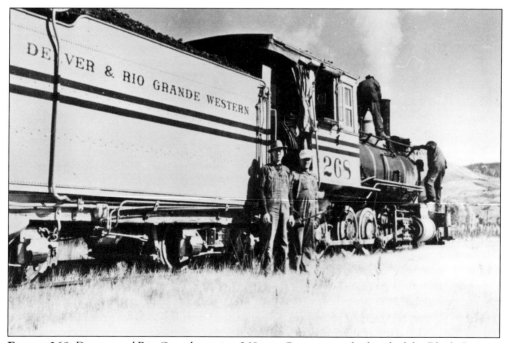

Engine 268. Denver and Rio Grande engine 268 is in Sapinero at the head of the Black Canyon before leaving on its last run to Gunnison in 1954. Conductor Ted McDowell and engineer Frank Wright sadly pose before their final trip.

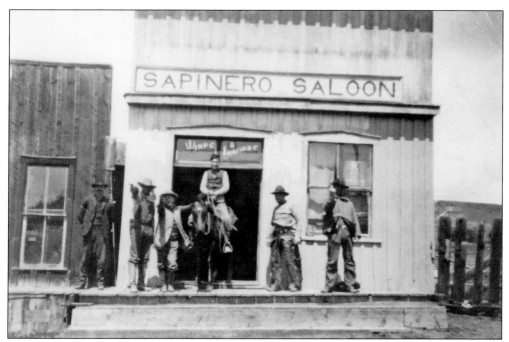

SAPINERO SALOON. Located at the head of the Black Canyon, Sapinero was on the Denver and Rio Grande Railroad line and became a major shipping point for the region west of Gunnison. Sapinero became a Rio Grande meal station and ranching center, and it was also the scene of much excitement on weekends when ranchers, railroaders, and locals came together to drink, dance, and party.

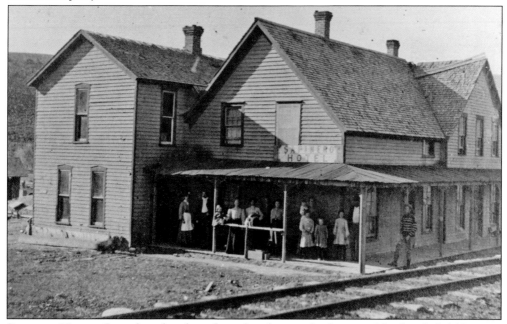

SAPINERO HOTEL. One of two hotels in the railroad town, the Sapinero Hotel included 20 rooms and a dining hall. The building was only a few feet from the railroad tracks and burned down in 1908.

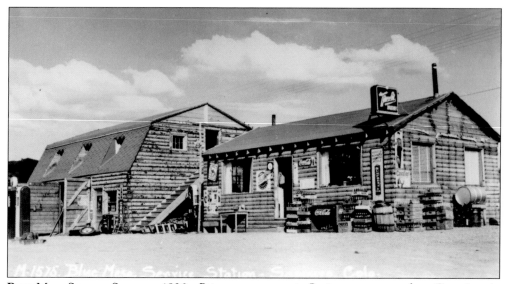

BLUE MESA SERVICE STATION, 1930S. Prior to gas pumps in Sapinero, gas came from Gunnison in heavy steel barrels. When a motorist bought gas, Rocco Santerelli, owner of the mercantile store, recalled, "We would put the barrel on a rack behind the store, draw gasoline out in half gallon pitchers and with the motorist holding the funnel, would try to pour most of it into his tank."

BURIED BRIDGES. This 1924 photograph shows the Sapinero Steel Arch Bridge, almost ready for use. This highway bridge was one of the famed "four bridges at Sapinero" and was very close to the start of the Black Canyon. It was eventually buried by the Blue Mesa Reservoir in the 1960s.

Seven

GUNNISON TUNNEL I

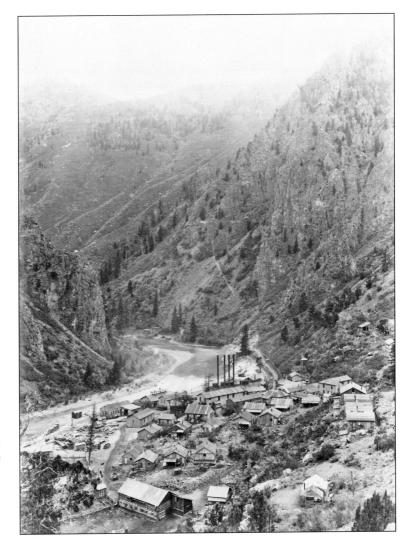

EAST PORTAL, 1906. The town of East Portal (or River Portal) was the site of the construction camp for workers. Visible are homes of the laborers as well as the construction building and power plant.

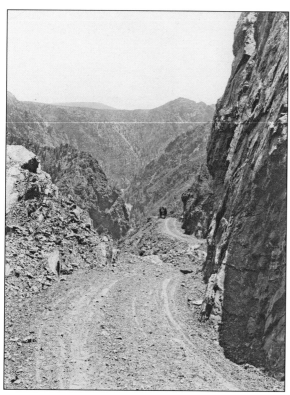

"THE ROAD TO HELL." The U.S. Reclamation Service completed a very steep road from Cedar Creek (Lujane or West Portal) to East Portal by November 1904. Grades ran as high as 23 percent and were so steep that one wagoner declared, "Four horse wagons going over it present the appearance of being almost all brakes." The road was the only one to reach the canyon for 70 miles.

WORKMEN AT EAST PORTAL. These hardy workers built the Gunnison Tunnel from its east end in the Black Canyon. Many had previously been hard-rock miners who had worked in San Juan mining camps like Telluride, Silverton, Ouray, and Lake City.

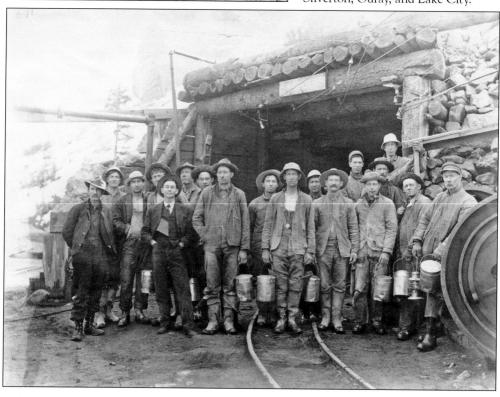

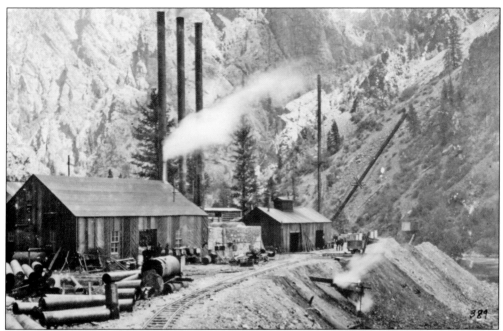

EAST PORTAL POWER PLANT. This power plant, set deep in the Black Canyon, provided the power to run drills and other machinery used by workers digging the Gunnison Tunnel. All new replacement machinery for the plant had to be brought in by a murderously steep road from the canyon rim above. This photograph also shows tracks running into the tunnel.

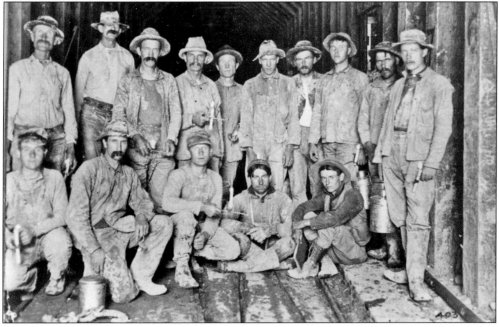

GUNNISON TUNNEL LABORERS. Some of the 500 men who worked on the Gunnison Tunnel pose in the cavern in 1906. The men dug the tunnel from four headings: one in from each portal and east and west from a shaft sunk into Vernal Mesa. In spite of good pay, the workers feared the hard and dangerous underground labor. The average stay for a tunnel worker was only two weeks.

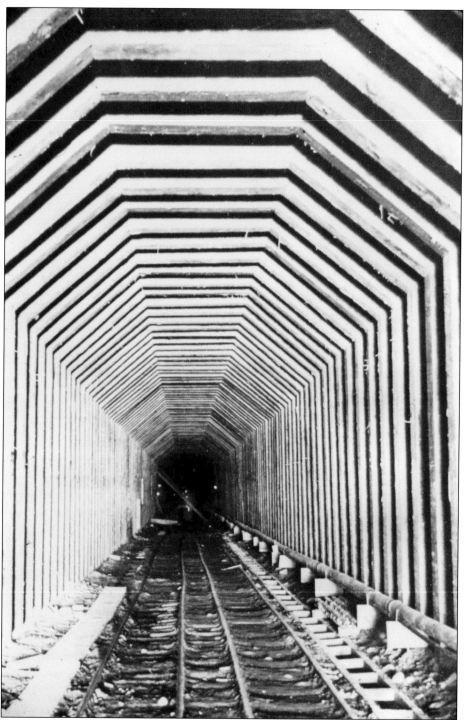

GUNNISON TUNNEL. Built by the newly formed U.S. Reclamation Service from 1905 to 1909, the Gunnison Tunnel was the first great Reclamation Service project in history. Working conditions were extreme. Pressurized water and carbonic gas knocked workers from their machines, temperatures got up to 90 degrees, and cave-ins were common.

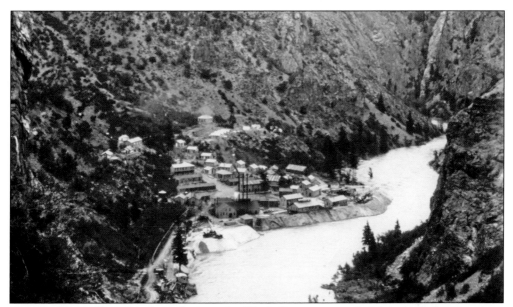

CANYON TOWN. East Portal was built in the Black Canyon on rock debris from the Gunnison Tunnel excavation and in part up the steep slope of the canyon. Each building had to have its own embankment foundation in order to give it room to stand. The total population at River Portal reached 140. The settlement was very difficult to supply from up above, and the Reclamation Service set up a milk ranch at the canyon rim.

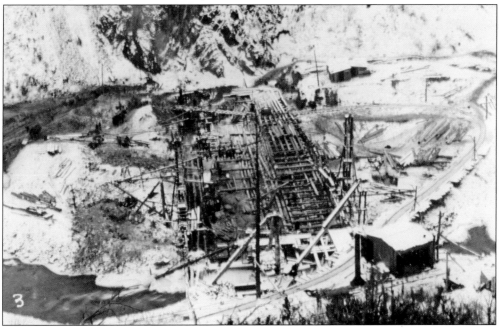

PROGRESS IN THE CANYON. Work progressed at River Portal in 1906. The Gunnison Tunnel was being constructed from four sites, including West Portal above the canyon and East Portal in the canyon. When completed in 1909, the tunnel measured 30,582 feet with dimensions inside of 10 feet by 10 feet. The grade of the tunnel was 2.02 feet per 1,000 feet from River Portal to West Portal.

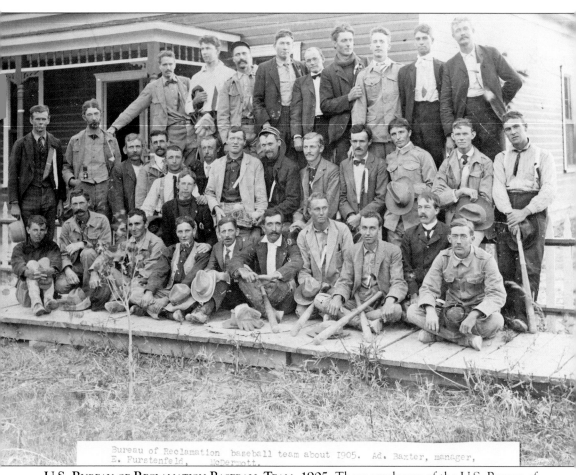

Bureau of Reclamation baseball team about 1905. Ad. Baxter, manager, E. Furstenfeld, McDermott.

U.S. BUREAU OF RECLAMATION BASEBALL TEAM, 1905. These employees of the U.S. Bureau of Reclamation were building the Gunnison Tunnel from the Black Canyon to the Uncompahgre Valley. On Sunday, their day off, the men had a crackerjack baseball team and regularly defeated teams from towns on the Western Slope.

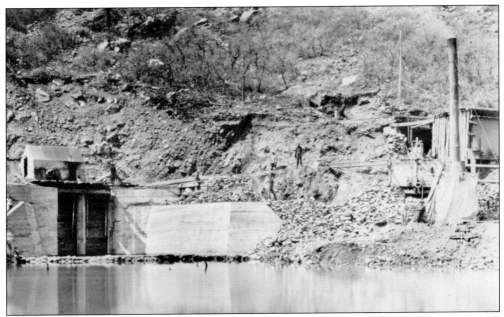

RIVER PORTAL. The River (or East) Portal of the Gunnison Tunnel was located deep in the Black Canyon. The site was a major problem when there was high water from the Gunnison River. Underground water was another problem. In one place, water pressure was so great that it forced blasting powder out of drill holes before it could be ignited.

RIVER PORTAL LOGS. Timber for the east side of the Gunnison Tunnel and for buildings at the River Portal had to be brought in via the treacherous road from above the canyon. This was no easy task. Grades were as great as 23 percent, 19 culverts had to be built, and freight to the River Portal cost $4.50 a ton. Very little went up the steep road except empty wagons.

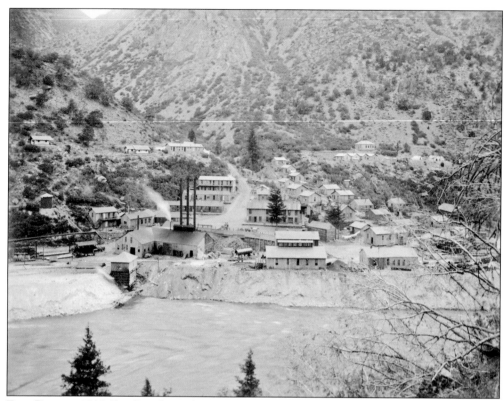

EAST PORTAL, 1907. East Portal was the construction site for Reclamation Service laborers working on the Gunnison Tunnel from its east side. In this photograph, one can see the power plant, worker cabins, and part of the steep 16-mile road that allowed supplies to be brought in.

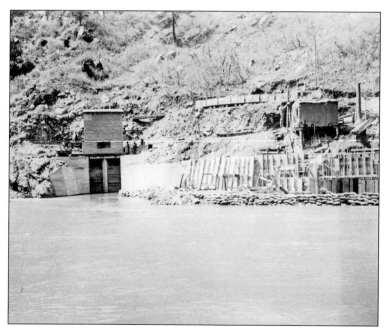

EAST PORTAL, GUNNISON TUNNEL. The Gunnison Tunnel was built following the expedition of Abraham Fellows and William Torrence in 1901. The East Portal of the tunnel is in the Black Canyon, and it was here that Gunnison River water was diverted under Vernal Mesa to the Uncompahgre Valley.

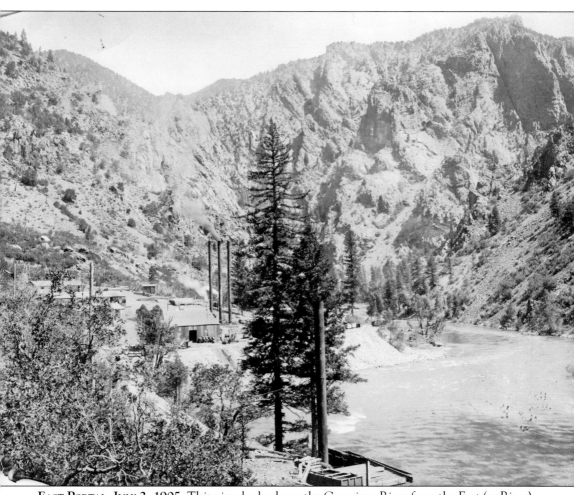

EAST PORTAL, JULY 2, 1905. This view looks down the Gunnison River from the East (or River) Portal of the Gunnison Tunnel. The power plant, with its three chimneys, powered the sawmill and other facilities needed during the tunnel's construction.

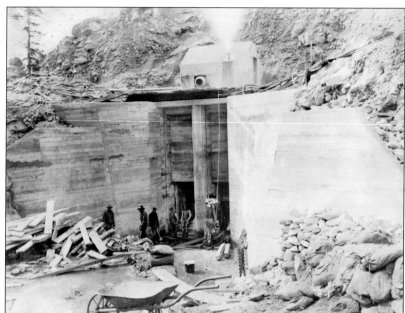

EAST PORTAL, 1905. Laborers seen here are working on the East Portal of the Gunnison Tunnel in the Black Canyon. The tunnel was built at a grade of 2 feet per 1,000 feet from River Portal to West Portal and carried 1,300 cubic feet of water per second.

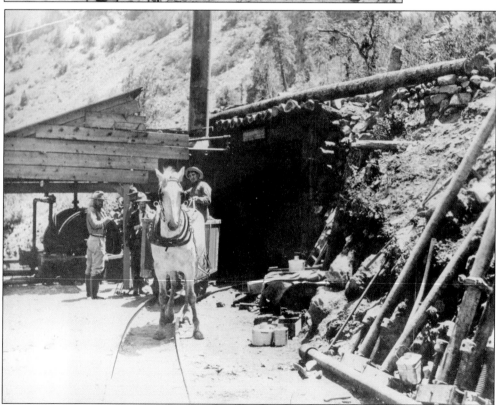

WORKERS AT EAST PORTAL. This shot was taken on July 2, 1905, at East Portal of the Gunnison Tunnel as a horse-drawn mining car removes diggings from within the tunnel. Much of the material removed was used for the base of workers' houses. Work in the tunnel was very difficult, featuring rockfalls, hot water, and unstable rocks.

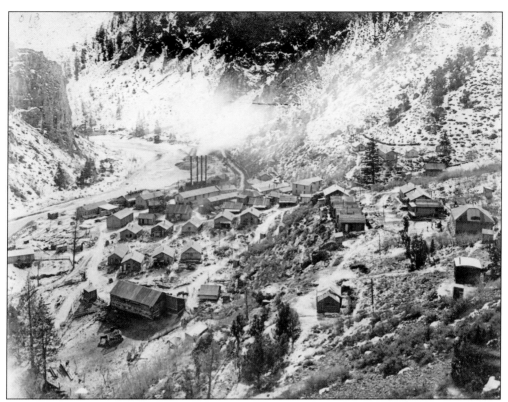

LIVING IN THE CANYON'S DEPTHS. At the bottom of the Black Canyon, River Portal was built on the dump from the Gunnison Tunnel and partly on the side of the gorge where each house had to have an embankment made to give it room for a base. Workers with good humor looked upon living at River Portal as "a kind of affliction."

TUNNEL WORK. Building the Gunnison Tunnel involved hard and dangerous work. The material through which the tunnel had to be driven included 2,000 feet of heavy, water-bearing alluvial clay, sand, and gravel; 1,200 feet of hard clay; 10,000 feet of shale; 2,000 feet of a shattered fault zone; and 15,000 feet of metamorphosed granite. In addition, the tunnel area was filled with seams of water under pressure.

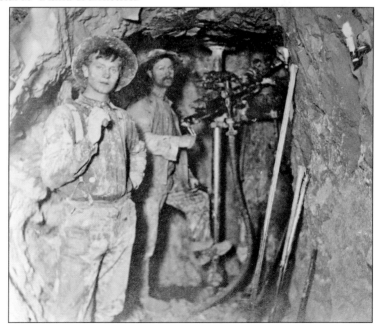

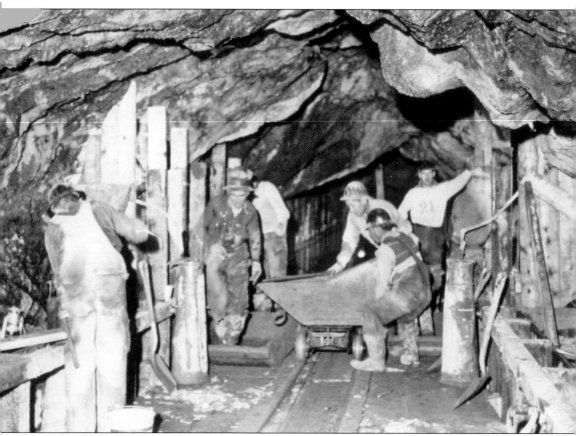

BUILDING THE TUNNEL. Workers are building the Gunnison Tunnel in 1906 near the River Portal, which involved very tough digging and drilling. The 15,000 feet of hard granite under Vernal Mesa slowed work considerably. It took 12 to 20 hours just to drill the holes for a round of blasting, after which muck had to be cleared before drilling.

Eight

GUNNISON TUNNEL II

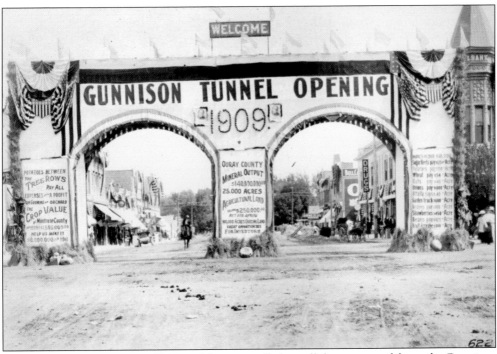

CELEBRATING THE GUNNISON TUNNEL. Montrose pulled out all the stops to celebrate the Gunnison Tunnel's opening on September 23, 1909. The Western Slope town, which had been withering on the vine because of the lack of irrigation water for its farm fields, was saved from disaster. The town's future now looked very bright.

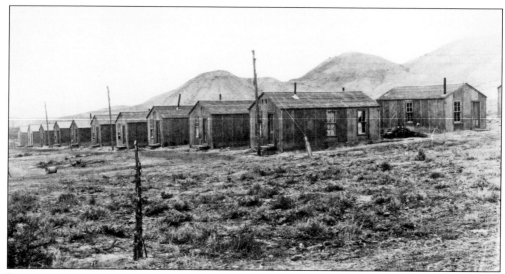

LUJANE, 1907. Lujane began in 1905 as the West Portal construction site for the Gunnison Tunnel. Here one can see the primitive accommodations for workers. Lujane gradually grew to 800 people, and it contained a post office, boardinghouse, two churches, and a hospital. Today no sign of the town survives.

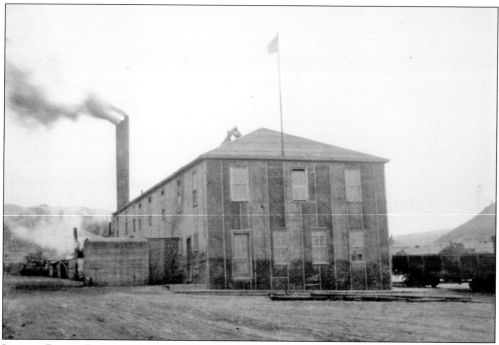

LUJANE POWER PLANT. Lujane (or West Portal) was located on the Uncompahgre Valley end of the Gunnison Tunnel, 7 miles east of Montrose. It was the construction site for workers on the west end of the tunnel. The power plant was only one of a number of major buildings at the construction site.

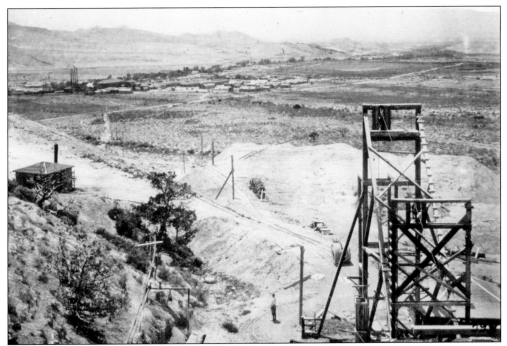

WEST PORTAL. Work is continuing on the Gunnison Tunnel at West Portal. Originally the work camp at West Portal was a mere collection of tents with poor water sanitation facilities. During the winter of 1904–1905, the camp was moved a mile to a better location. The town eventually employed 350 men and grew to 800 inhabitants. The construction site was always called West Portal, but the post office name was Lujane.

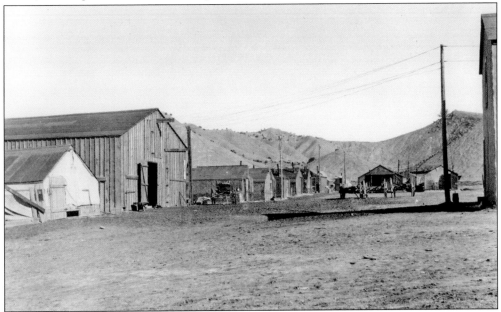

LUJANE: A FLEETING TOWN. Lujane housed construction workers building the Gunnison Tunnel, along with their families. The town only existed for five years; following the completion of the tunnel, Lujane faded into oblivion.

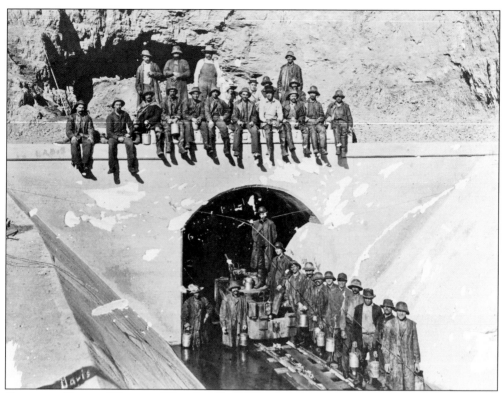

GUNNISON TUNNEL WORKERS. This photograph shows the rugged and hardworking laborers who built the Gunnison Tunnel, most pictured here with their lunch buckets. The construction tram is at the tunnel entrance at the East Portal.

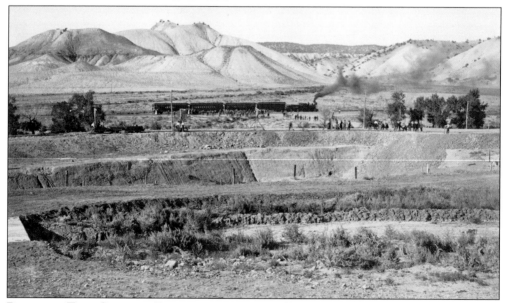

PRESIDENT TAFT COMES TO LUJANE, 1909. Pres. William Howard Taft's special train arrives in Lujane in September 1909. Taft inspected the tunnel site and thanked the hardy men who helped build it.

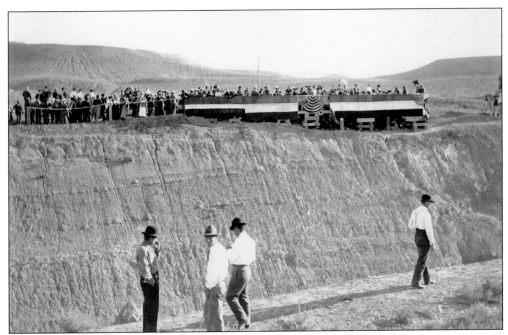

SPEAKER STAND FOR PRESIDENT TAFT. A crowd begins to gather near Lujane and photographers get ready a couple hours before the arrival of President Taft, who was there to celebrate the opening of the Gunnison Tunnel. In front of the stand is one of the many ditches that would carry water to irrigate the Uncompahgre Valley.

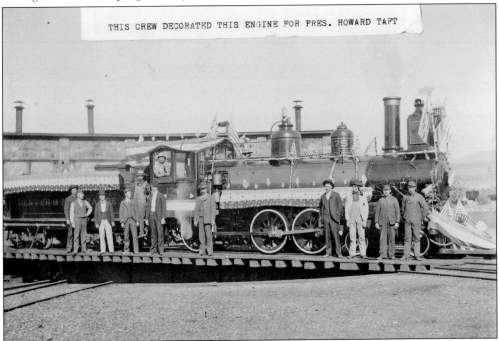

THIS CREW DECORATED THIS ENGINE FOR PRES. HOWARD TAFT

D&RG ENGINE DECORATED FOR TAFT. "Old Tucker," a narrow-gauge engine, was decorated in Montrose for the arrival of Pres. William Howard Taft at the dedication of the Gunnison Tunnel in September 1909.

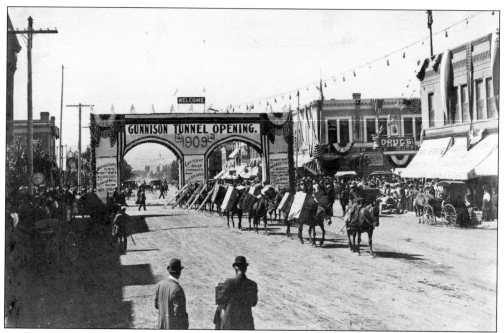

GUNNISON TUNNEL CELEBRATION, 1909. The city of Montrose celebrated the opening of the Gunnison Tunnel on September 23. Here a line of pack mules, celebrating the great mining tradition of the nearby San Juan country, parades down the town's main street.

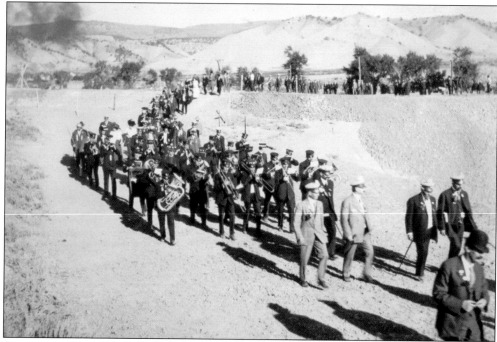

SEPTEMBER 23, 1909. A huge party of dignitaries, including a marching band, makes its way toward Lujane (or West Portal) of the Gunnison Tunnel. An hour later, the entourage and spectators celebrated the opening of the tunnel, sending Gunnison River waters to the Uncompahgre Valley.

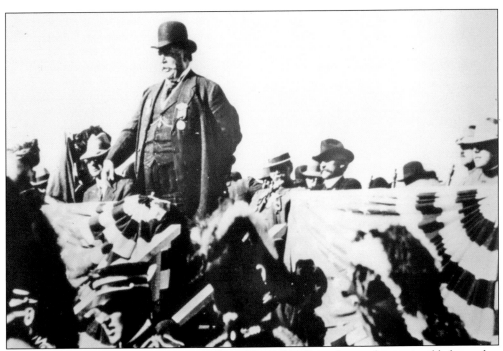

PRESIDENT TAFT IN MONTROSE. Pres. William Howard Taft speaks to a huge assembled crowd at Montrose, Colorado, on September 23, 1909. Taft made the long journey to the West to dedicate the first great U.S. Reclamation Service project in history—the building of the Gunnison Tunnel.

TAFT AND THE TUNNEL. Pres. William Howard Taft arrived by railroad on September 23, 1909, to dedicate the Gunnison Tunnel. Since the diversion dam was not yet built across the Gunnison River, none of the river water could be sent through the tunnel. Because of that, workmen built a small dam in the tunnel to hold back seepage. When Taft tapped the silver bell, seen in this picture, the workers broke open the dam and a small flow of water emerged to the delight of the gathered audience.

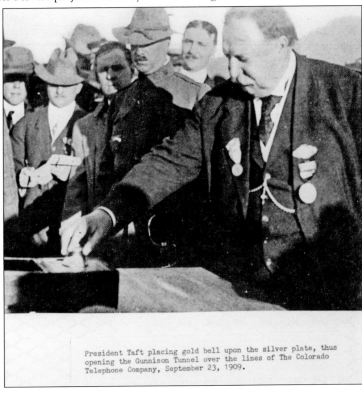

President Taft placing gold bell upon the silver plate, thus opening the Gunnison Tunnel over the lines of The Colorado Telephone Company, September 23, 1909.

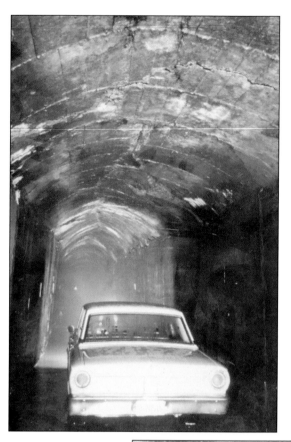

CHECKING THE GUNNISON TUNNEL. An automobile, driven by an Uncompahgre Valley Water Users Association ditch rider, makes its way through the Gunnison Tunnel on January 1, 1966. The photograph was taken at station 175. The tunnel was nearly dry and the ditch rider was checking the tunnel for any damage or defects.

INSIDE THE GUNNISON TUNNEL. A ditch rider in a pickup truck makes his way through the Gunnison Tunnel in the fall of 1968. Irrigation in the Uncompahgre Valley is over and the ditch rider is making the 6-mile drive from the West Portal to the East Portal.

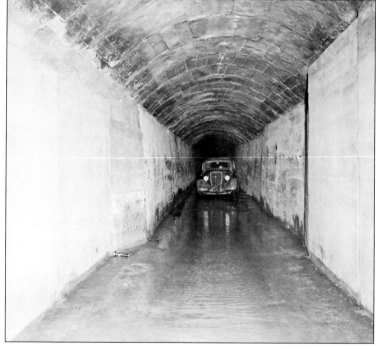

Nine

The Adventurers

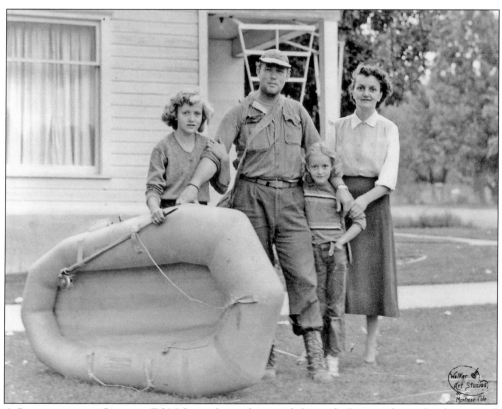

A Legend of the Canyon. Ed Nelson, shown here with his wife, Joni, and two daughters, Joed (left) and Leah, became famous locally and around the nation for his trip through the Black Canyon in September 1949. With this one-man rubber boat, a small amount of food, a light bedroll, and fishing rod and flies, Nelson started on the Gunnison River at East Portal and in an epic five-day trip finished near the canyon's end minus a camera but alive. His trip was reported through national news services and national broadcasts. Nelson knew the canyon better than anyone because of his fishing excursions. A veteran river rat from Montrose, Nelson ran the Gunnison River through sections of the Black Canyon more than 250 times. The canyon was a regular run for Nelson from 1949 to the mid-1970s. Two of his frequent river runners were Gov. John Love of Colorado (1962–1973) and well-known newspaper reporter Red Fenwick. Nelson was often called to rescue those who got in trouble in the Black Canyon and on a couple of occasions to collect bodies of those who did not survive the gorge. Nelson's son, on the Gunnison River that his father ran so many times, commented, "If you were to rate the Gunnison in the area from the base of Morrow Point Dam to the East Portal, it was in numerous areas at least a class five." Of all who have been involved with the Black Canyon, Ed Nelson knew it the best and was the best boatman.

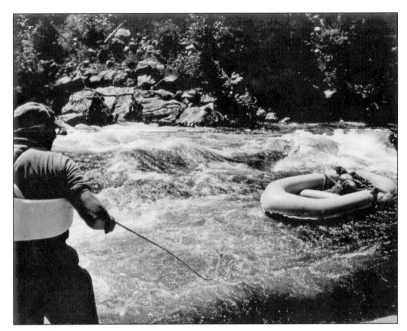

LINING THE BOAT. Ed Nelson lines his boat through some violent water in the Black Canyon during one of his many expeditions through the gorge. He knew the canyon like no one before or since.

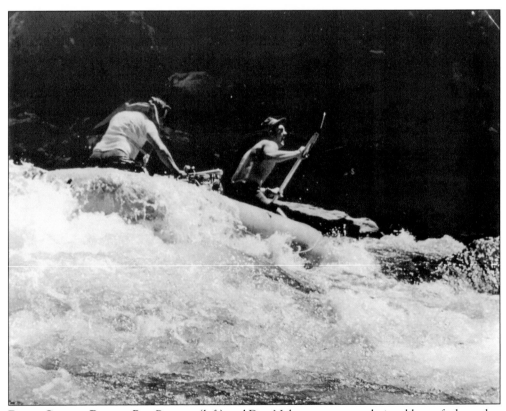

BLACK CANYON RAPIDS. Rex Pearson (left) and Dan Nelson maneuver their rubber raft through a rough section of the Black Canyon in 1972; the men were running the Gunnison River between Cimarron and East Portal and all eyes were on a huge, and dangerous, approaching rapids.

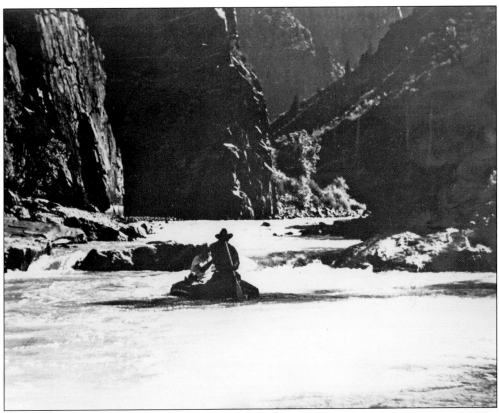

Boating in the Canyon. Most of the Gunnison River in the Black Canyon could not be run by boat because of waterfalls, the tremendous drop of the river, and the huge rocks in the middle of the stream. Here is a part of the canyon where a boat can be used, but even this section demands much skill.

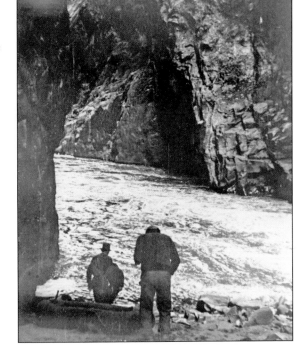

Danger at the Narrows. Two men, with their boat in back of them, gauge the fast-flowing and dangerous waters of the Gunnison River as it roars through the Narrows in the Black Canyon in 1932. Very few have dared to challenge the Narrows.

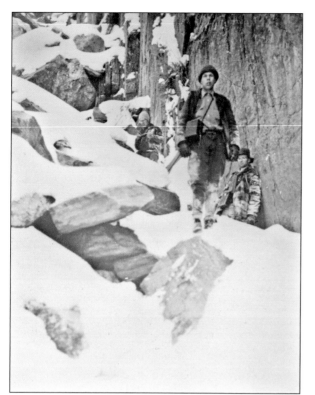

DAVID LAVENDER IN THE BLACK CANYON. Famed Western historian David Lavender ventured into the Black Canyon as a young man in the 1930s. His party believed a winter expedition would be easier than during other times of the year. However, heavy snow and not being able to walk on top of expected ice forced an end to the effort.

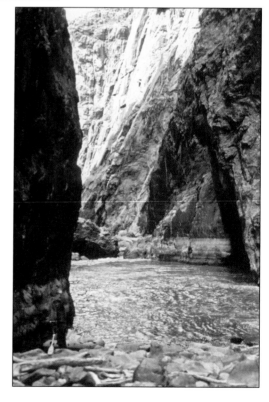

THE NARROWS, AUGUST 1972. From August 19 to August 23, 1972, a three-man party consisting of David Nix, John Hrovat, and author Duane Vandenbusche, all from Colorado, traversed the Black Canyon from Cimarron to its end near Lazear. Vandenbusche is along one vertical wall. One can see along the canyon wall a lighter color, showing how much higher the water could get in the Narrows before dams were built in the gorge.

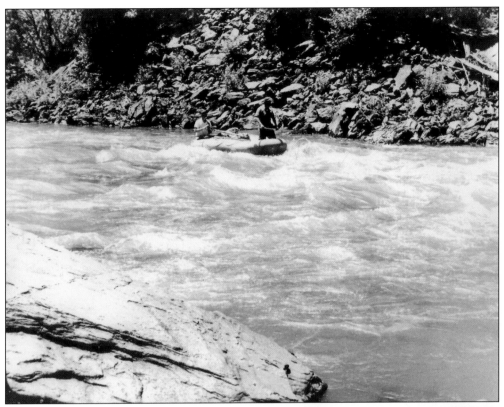

RUNNING THE GUNNISON RIVER. One of Ed Nelson's boats navigates through the Black Canyon in the 1960s. Nelson knew the canyon like no other person. A great athlete who lettered in football, track, and boxing at the University of Colorado, Nelson was fearless in the canyon. He went on to become manager of the Montrose Chamber of Commerce and was also on the Colorado Movie Commission. He worked to bring movies like *How the West Was Won*, *The Unsinkable Molly Brown*, and *True Grit* to the Montrose area.

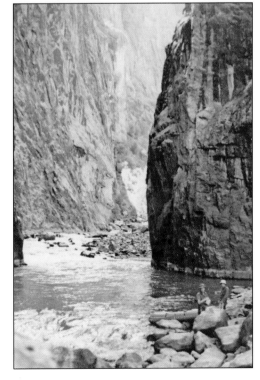

THE NARROWS, 1972. One of the most dangerous places in the Black Canyon, the Narrows is so named because the canyon walls are only 44 feet from each other. Here the cliffs are over 2,000 feet above the Gunnison River and there is no shore on either side. One must go through by boat or swim. It is imperative that he or she exit the river on the south side when the Narrows end because of danger below.

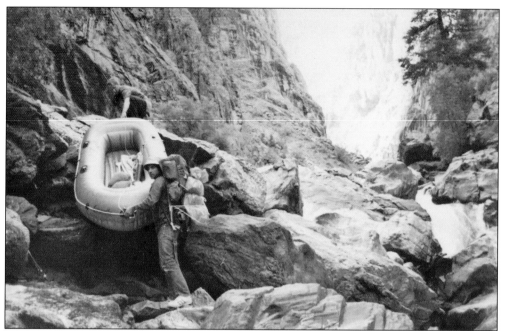

BLACK CANYON STRUGGLES. The author (above) and John Hrovat are portaging a 33-pound Caravel boat above a roaring Gunnison River in their 1972 expedition through the Black Canyon. The two men, along with fellow boatman Dave Nix, found that Abraham Fellows and William Torrence, who went through the canyon in 1901, had been right not to take boats in the demanding gorge.

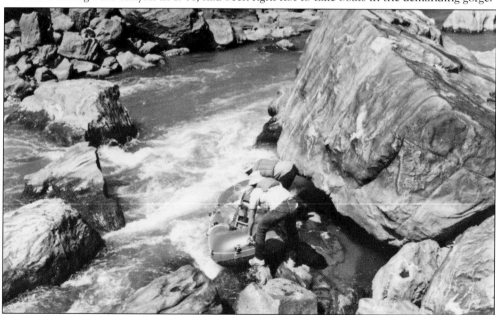

NIX AND HROVAT, BLACK CANYON, 1972. Dave Nix and John Hrovat (foreground) portage their boat through some violent Gunnison River water deep in the Black Canyon. The party, which also included the author, took 100 feet of silk rope, life preservers, ponchos to sleep in, and iodine tablets to purify river water for drinking. The trip from East Portal to the end of the canyon took four days.

RON MASON, U.S. OLYMPIC KAYAKER. In the 1970s, Ron Mason, one of the finest kayakers in the world, took a small party into the Black Canyon at Cimarron, 15 miles from its head. He and his party became the first ever to succeed kayaking the turbulent waters of the Gunnison River.

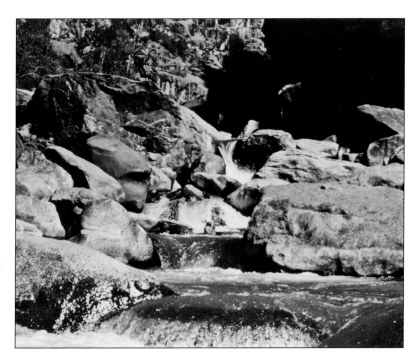

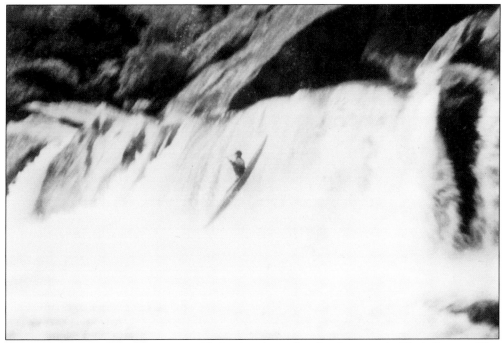

KAYAKER'S DELIGHT. Ron Mason, a world-class kayaker, takes the plunge in the Black Canyon. This waterfall is over 20 feet high and after the fall, one must be able to pull out of the backwater below. Many world-class kayakers have tested their skills in the violent waters of the Black Canyon.

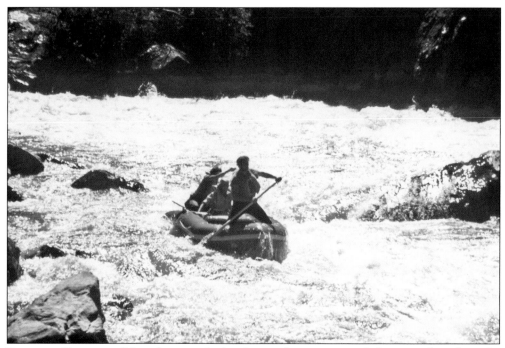

RUNNING "LEAPFROG." Leapfrog was the local name for a quarter-mile-long set of rapids in the Black Canyon between Cimarron and East Portal. This 1975 photograph shows Jim Hanks in front, Marianna Hviiding in the middle, and the author in back of an Avon Red Shank raft maneuvering in the middle of the turbulent water.

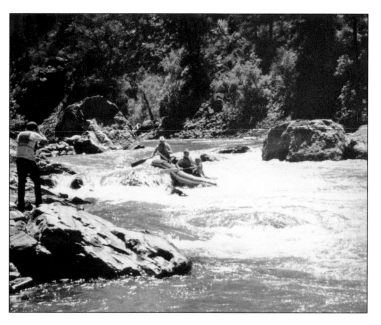

COLORADO GOVERNOR RICHARD LAMM. In August 1975, Gov. Richard Lamm, an accomplished kayaker and boatman, made his first trip through the Black Canyon from Cimarron to East Portal. Lamm is in the middle of the Avon Red Shank with Gordon Zapp in the back and Marianna Hviiding in front. Jim Hanks is on the left snapping pictures.

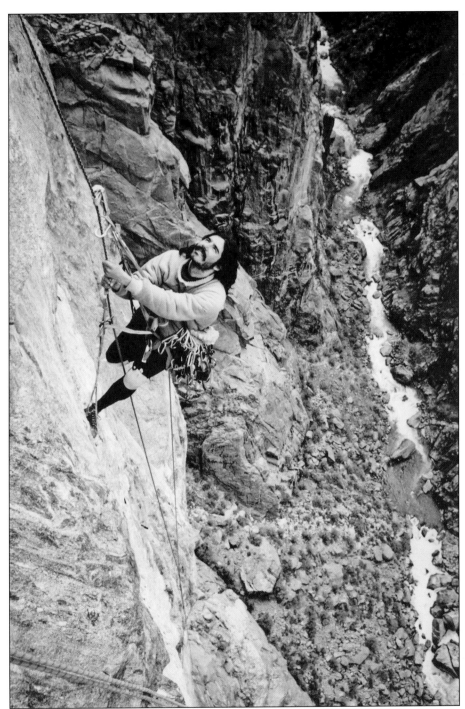

Jim Newberry on Hallucinogen. With the Gunnison River far below, Jim Newberry climbs the Hallucinogen Wall in May 1980. The climb, which included Bryan Becker, Bruce Ella, and Ed Webster, took eight days. The Hallucinogen route, part of North Chasm in the Black Canyon, had never been climbed. In this photograph, Newberry is 700 feet from the top of the 1,700-foot wall and it is only the fifth day of the climb.

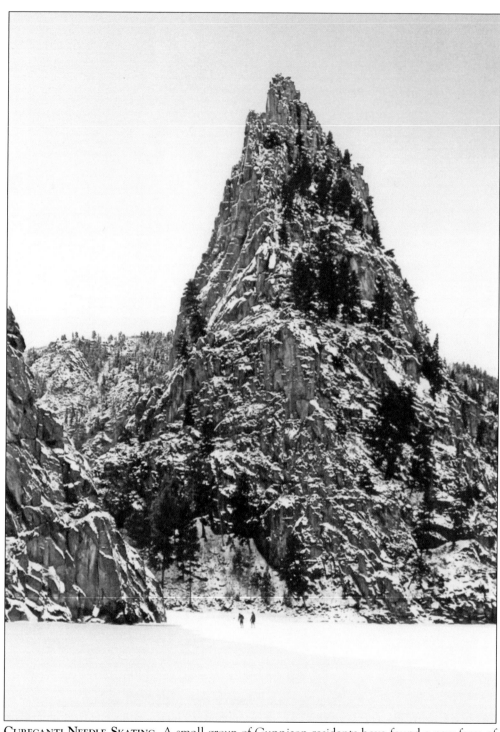

CURECANTI NEEDLE SKATING. A small group of Gunnison residents have found a new form of recreation in the Black Canyon—ice-skating. Using the Curecanti Trail to get into the gorge, the ice-skaters are able to skate on top of the Gunnison River in the shadow of the Curecanti Needle.

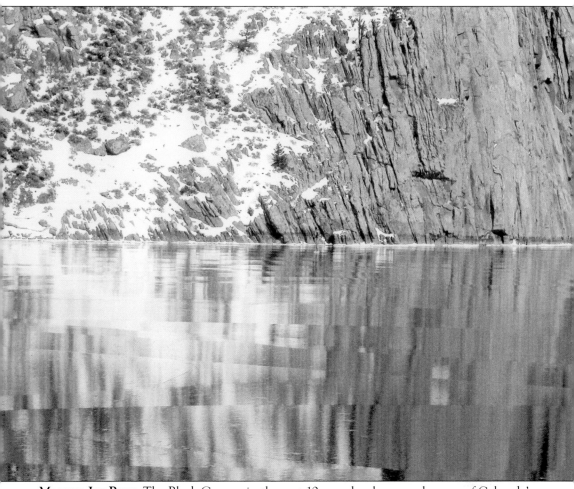

Massive Ice Rink. The Black Canyon in the past 10 years has been used as one of Colorado's largest ice rinks by local skaters. East and west of the Curecanti Needle, on ice atop the Gunnison River, locals and friends can skate for miles. Skating is the latest form of recreation in the Black Canyon.

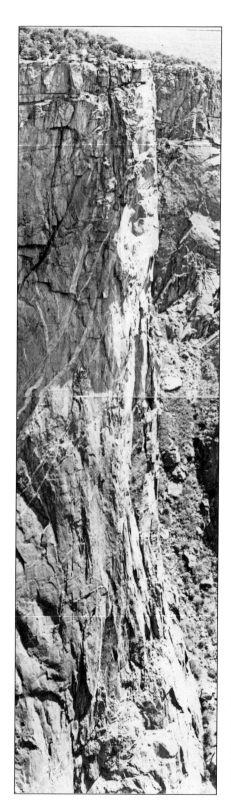

HALLUCINOGEN IN THE BLACK CANYON. The Hallucinogen Wall on the north side of the canyon, near the Chasm view, is one of the most challenging climbs in Colorado. At 1,700 feet high, the wall is classified as a grade 6, 5.11 A4+. At the time it was first climbed in 1980, it was the hardest route in Colorado. It was so named because looking at it from the South Chasm wall, there appears to be no way to climb it.

Ten

POTPOURRI

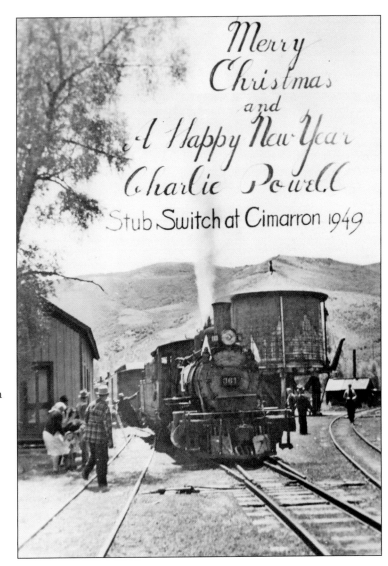

Merry Christmas and A Happy New Year Charlie Powell

Stub Switch at Cimarron 1949

CHRISTMAS DAY, 1949. The weather was mild in Cimarron on Christmas day in 1949. A Denver and Rio Grande freight train is stopped at the switch in town. The railroad furnished most of the jobs for the little village, but the day of the railroad was coming to an end.

CIMARRON, 1880s. After running its line through the Black Canyon from Sapinero, the Denver and Rio Grande Railroad came out of the canyon at Cimarron. When the railroad arrived in August 1882, Cimarron had a general store, several eating houses, 11 saloons, and many cattle pens.

CIMARRON, 1886. Cimarron was the end of the line for the Denver and Rio Grande Railroad in the Black Canyon. Beyond the little town, the canyon proved to be too dangerous. An early traveler in 1886 recalled, "The little village has a lonely, dreary appearance, but after a few days it seems as if the mountains, trees, birds, and trout are bidding welcome."

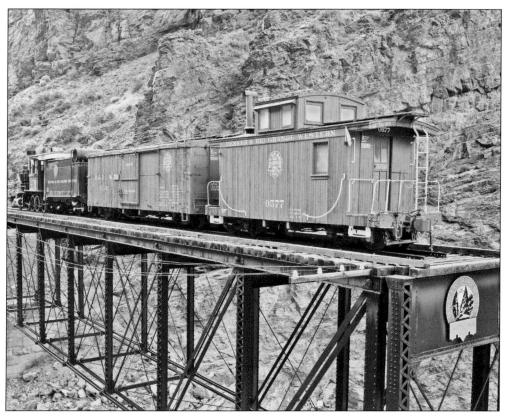

ENGINE 278 AT CIMARRON. This Denver and Rio Grande engine was used to pull trains through the Black Canyon from 1882 to 1949. Today it sits on an original bridge just below Cimarron and is much photographed.

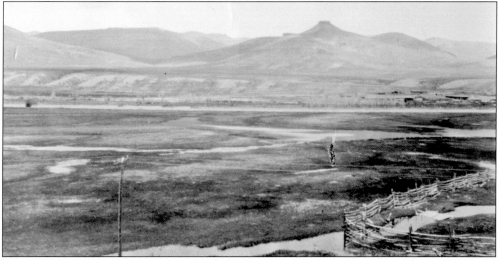

UNCOMPAHGRE VALLEY, 1890S. Water from the Uncompahgre River proved insufficient for the needs of farmers and ranchers who flocked in after 1882. Foreclosures were many, and even communities like Montrose were threatened. The only hope to survive was water from the Gunnison River in the nearby Black Canyon.

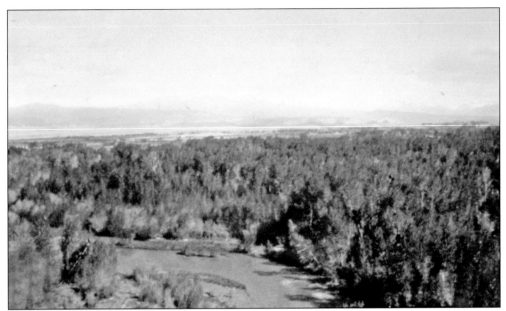

UNCOMPAHGRE VALLEY POSSIBILITIES. With Montrose in the middle, the valley was withering on the vine by the 1890s. The valley had 175,000 irrigable acres of land but the Uncompahgre River, which flowed through it, could only irrigate 35,000. If Gunnison River water flowing through the Black Canyon could be diverted underneath Vernal Mesa, the valley would be saved.

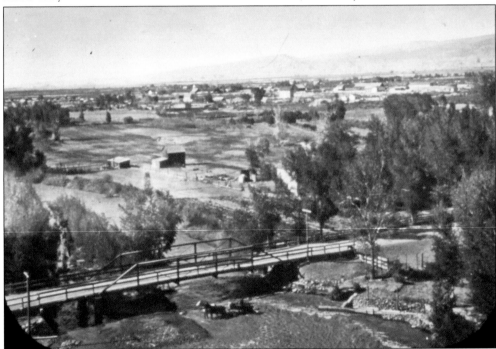

CROSSING THE UNCOMPAHGRE RIVER. A bridge spans the Uncompahgre River, seen here on May 18, 1901, with Montrose in the background. These were desperate years for farmers and ranchers of the Uncompahgre Valley. As more and more people came to the valley, it soon became obvious that there was not enough water for irrigation. The valley appeared to be doomed.

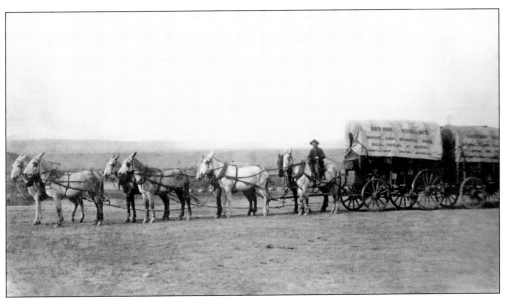

DAVE WOOD, GREAT FREIGHTER OF WESTERN COLORADO. Dave Wood's base operation was in Montrose and later the little town of Dallas. He hauled supplies taken through the Black Canyon by the Denver and Rio Grande Railroad to the mining camps of western Colorado and also carried ore from the camps to nearby smelters.

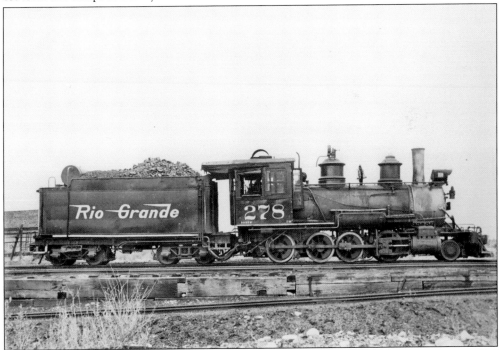

DENVER AND RIO GRANDE NARROW GAUGE. The Denver and Rio Grande Railroad was called "the biggest little railroad in the United States" and the "Scenic Line of the West." Running on tracks 3 feet wide, the Denver and Rio Grande went through some of the highest and toughest mountain country in the West. Engine 278, seen here in Montrose, was a regular visitor to the Black Canyon.

FLOURISHING UNCOMPAHGRE VALLEY. The Gunnison Tunnel saved the Uncompahgre Valley. By 1925, over 61,000 acres were irrigated by Gunnison River water. Total crop production was over $3 million. The principal crops grown were alfalfa, wheat, potatoes, oats, sugar beets, corn, onions, apples, and beans. The Uncompahgre Valley was now one of the most productive in Colorado.

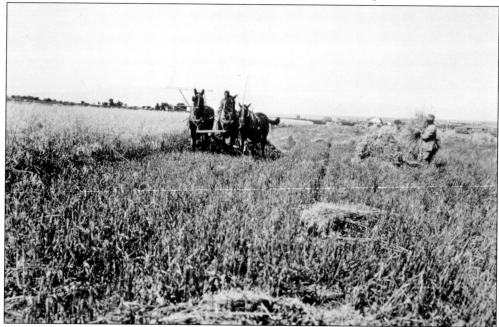

WHEAT HARVEST. Following the construction of the Gunnison Tunnel in 1909, life-giving Gunnison River water flowed into the Uncompahgre Valley, spurring an agricultural boom. Wheat became a major crop. This photograph shows a Montrose farmer harvesting a great yield of the grain.

THE MONTROSE DEPOT. A Denver and Rio Grande engine waits on newly laid tracks at Montrose in the early 1880s. The Western Slope town had just begun, and the railroad had recently arrived. It was the beginning of a new era for western Colorado.

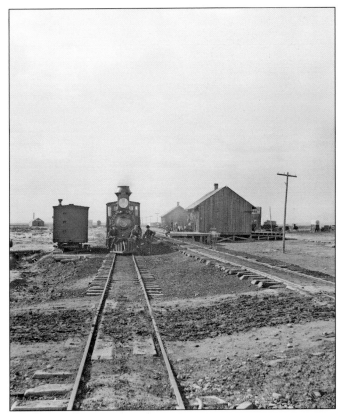

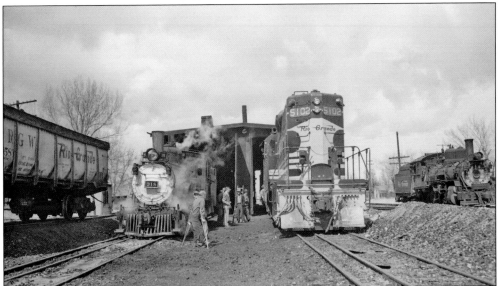

"THE LARGE AND THE SMALL." Two Denver and Rio Grande engines stand side by side around the beginning of the 20th century. The smaller of the two is a narrow-gauge engine running on tracks 3 feet wide. The larger engine is broad gauge and it ran on tracks 4 feet, 8.5 inches wide. One can also see the third rail in front of the broad-gauge engine, which allowed both narrow- and broad-gauge travel.

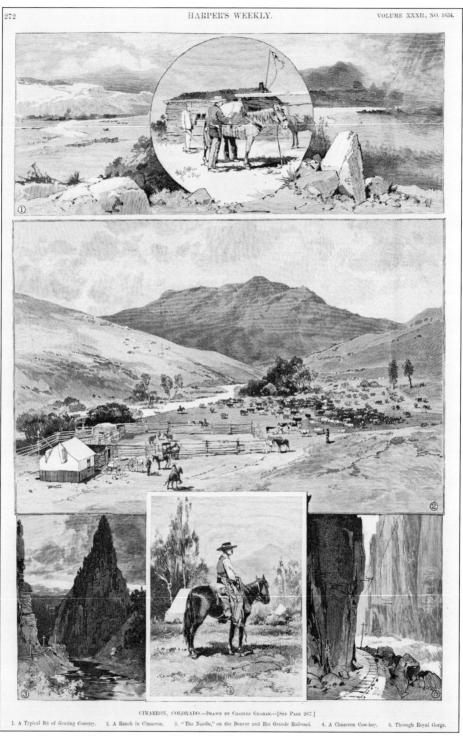

CIMARRON, COLORADO.—DRAWN BY CHARLES GRAHAM.—[SEE PAGE 267.]

1. A Typical Bit of Grazing Country. 2. A Ranch in Cimarron. 3. "The Needle," on the Denver and Rio Grande Railroad. 4. A Cimarron Cow-boy. 5. Through Royal Gorge.

HARPER'S WEEKLY: BLACK CANYON. *Harper's Weekly* sent an artist out to western Colorado in 1881 to capture the wondrous Black Canyon. Shown in the drawings are Cline's Ranch (soon to be renamed Cimarron), the Curecanti Needle, and the rugged walls of the Black Canyon.

DAM CONSTRUCTION.
Construction began on the
Blue Mesa Dam just west of
Sapinero in the 1960s. The
dam was one of seven built by
the Bureau of Reclamation as
part of the Upper Colorado
River Storage Act of 1956.
The dam was built to
store water for the Lower
Basin states of Arizona,
California, and Nevada.

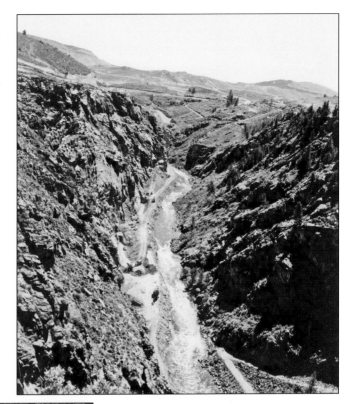

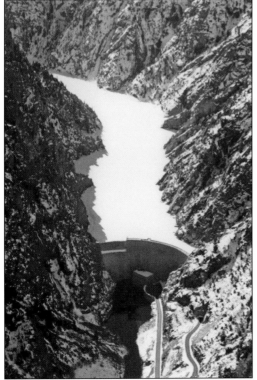

MORROW POINT DAM. One of three dams
in the Black Canyon, Morrow Point is 12
miles below the Blue Mesa Dam and 38
miles west of Gunnison. The dam was
built in 1968 and is a concrete, double-
curvature, thin arch structure that stands
469 feet high. The reservoir, backed up
by Morrow Point, has a huge storage
capacity of 117,190 acre feet of water.

123

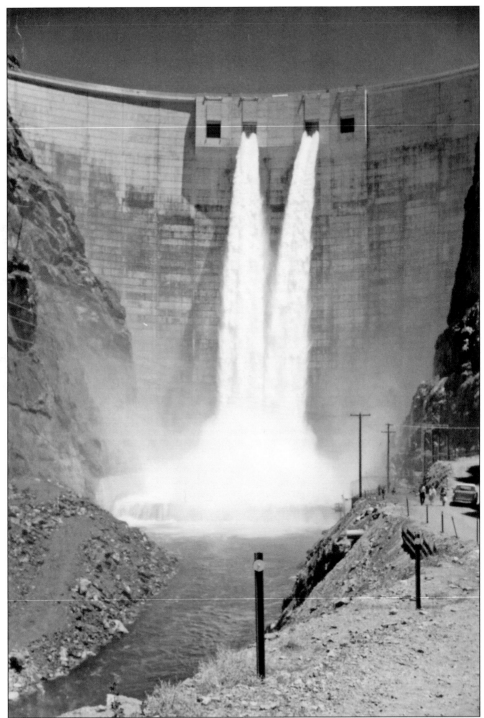

MORROW POINT OVERFLOW. The second dam to be built in the Black Canyon, Morrow Point was constructed primarily for power generation. It contains two 83,000-horsepower turbines capable of producing 172,000 kilowatts of power. Rarely does the dam overflow as seen in this 1970s photograph.

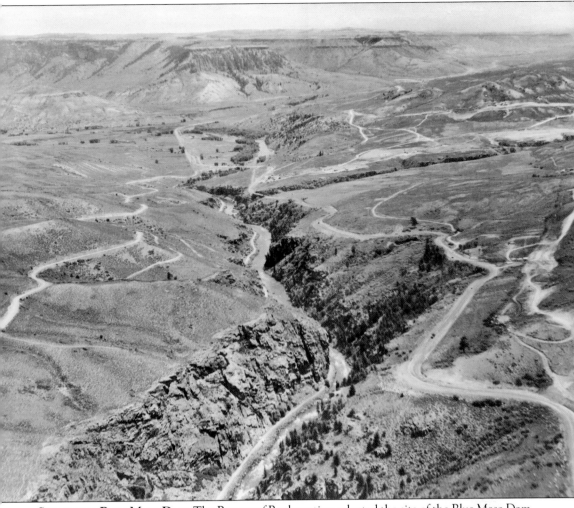

Site of the Blue Mesa Dam. The Bureau of Reclamation selected the site of the Blue Mesa Dam 1.5 miles below Sapinero. This early-1960s photograph shows the site at the head of the Black Canyon with Sapinero in the background and the old Denver and Rio Grande Railroad grade in the canyon. Ground-breaking on the dam took place on July 7, 1962.

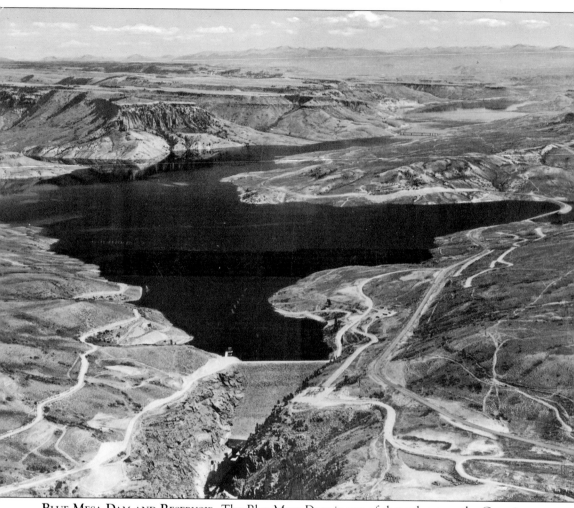

BLUE MESA DAM AND RESERVOIR. The Blue Mesa Dam is one of three dams on the Gunnison River and is part of the Curecanti Project. This earthen dam was completed in 1965 and backs up a reservoir that is the second-largest tourist attraction in Colorado behind Rocky Mountain National Park.